ABSTRACTS
50 Inspirational Projects

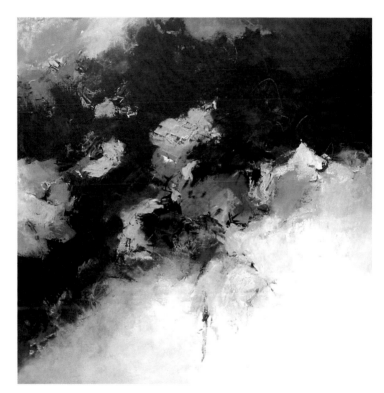

Acrylic on canvas, 80 × 80cm (31½ × 31½in), by R. van Vliet.

Why paint in the abstract style?

Working abstractly and learning to abstract are excellent ways of developing your own talent and artistic ability.

- Abstraction gives you the perfect opportunity to free yourself from traditional and common ways of working, to take a fresh approach and develop your own personal style.

- Abstract work calls principally on abilities such as feeling, emotion, intuition, creativity and spontaneity, as well as your feeling for form, colour, composition, harmony and so on. These abilities lie at the heart of all forms of pure art.

- Even if you have no experience of drawing and painting, the abstract method will allow you to develop expressive painting skills without any complicated techniques.

- If you prefer to continue painting from reality, abstraction is the ideal way to give your own interpretation to that reality.

- Working abstractly frees you from painting 'pictures' or painting by example.

- It paves the way to originality and individuality.

- It stimulates you to experiment, discover and create.

- The totally free way of working adds an extra dimension to your painting experience.

Just try it and see for yourself!

ABSTRACTS

50 Inspirational Projects

Rolina van Vliet

SEARCH PRESS

Contents

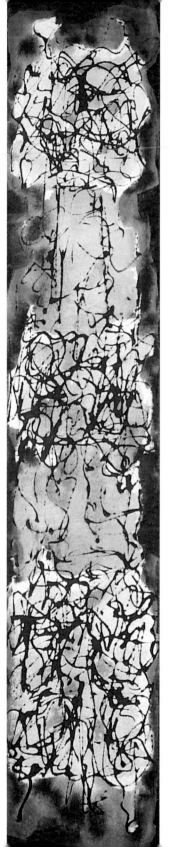

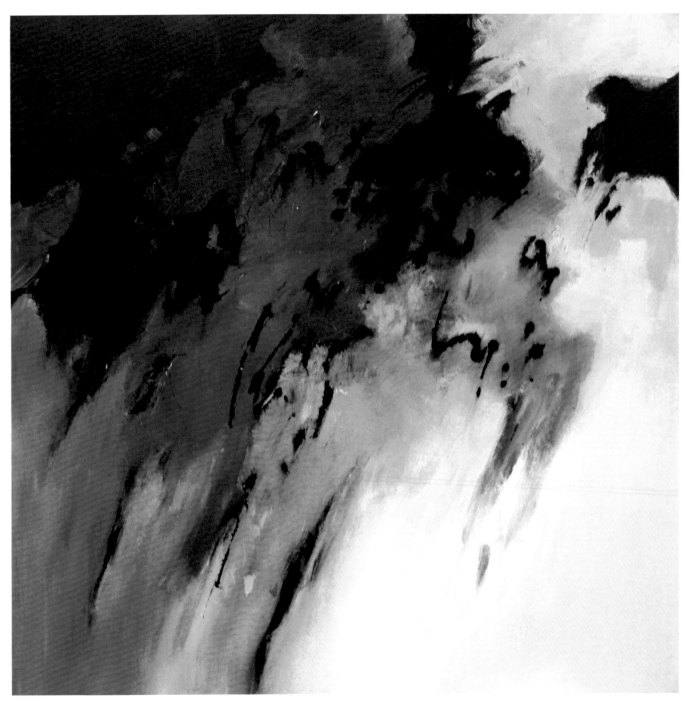

Acrylic on canvas, 100 × 100cm (39 × 39in), by R. van Vliet.

Introduction

The outstanding success of my previous books, *The Art of Abstract Painting* and *Painting Abstracts: Ideas, Projects and Techniques,* has led me to put together this third book, which once again deals with abstract painting. This is a style of painting that, due to its expressive nature, is perfectly suited to current times, in which we value freedom of action and individual creativity, and are constantly looking for new forms of expression. Abstract painting provides an opportunity for achieving this goal in a way that no other painting style can.

The Art of Abstract Painting describes the theory and background behind the Abstract Painting Method that I devised ten years ago. It is a new and unique method of painting that helps you understand how abstract painters work. *Painting Abstracts* focuses on the practical side and comprises a collection of studies that describe in full the process of producing a painting.

You are now holding a copy of *Abstracts: 50 Inspirational Projects.* This book focuses on the important questions: 'What do I paint?' and 'How do I paint it?' Even abstract painters often have trouble finding new ideas – how to start a painting and where to get ideas from. This book is crammed full of ideas, concepts and starting points that will not only inspire you but will also, importantly, show you how to find ideas on your own.

As this is a manual, I have paid a lot of attention to practising your painting. Just as in *Painting Abstracts,* you will find study tasks that describe the painting process in detail. Together with the illustrations, these come directly from the lessons that I have taught over the last ten years during my courses and workshops. You can therefore now follow the same course as my students; indeed, it is unique to find so much study material conveniently arranged in one book. With its help, I would like you to become familiar with my lessons and the Abstract Painting Method, and to experience and discover what freedom and expression can mean for you.

Rolina van Vliet

1 Abstract – a definition

Before carrying out the studies in this book, you need to understand the Abstract Painting Method and what the concept 'abstract' means. The dictionary gives the following definition:

Abstract (from Latin, *abstractus*) = removed from reality, disconnected from what is observed, intangible, not imaginable as a shape, cannot be named as an existing, concrete thing.

To abstract = to derive from what is perceived, to set apart, to remove.

Abstract art can be described as art that does not have any recognisable relationship to visible, concrete reality. It uses elements such as shape, colour and line and creates its own reality from these. It is also referred to as non-representative, non-figurative or non-depictive art. Furthermore, abstract art can originate from reality when it is a derivation of this.

Therefore within abstract painting we can identify two starting points:

A There is no relationship with reality Here our work is completely abstract. Shapes, colours, textures and lines have no simple relationship to anything recognisable but are used purely as non-figurative, abstract picture elements.

B There is an original relationship with reality In this case we use shapes and depictions from reality and apply the rules of abstraction to these in order to create something individual and unique.

Abstraction

As abstract painters, when we depart from reality, we will primarily make use of abstraction, which is making reality more abstract, to the point that it is barely recognisable. In this way of working, we use reality, but do not copy it. It is a more challenging way of showing the things around us in our own individual way. Reality, therefore, acts as a stimulus. We do not let it dictate which shape or colour we should use, but rather freely create our own, new reality.

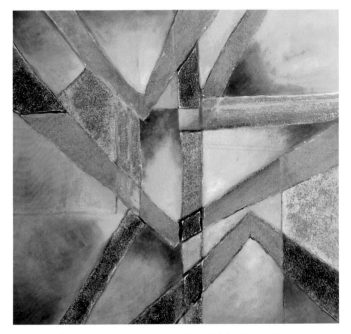

Mixed media on canvas, 40 × 40cm (16 × 16in), by H. van Gemeren.

From figurative to abstract

There are various steps we can take when we want to use something concrete from reality – such as a tree, flower or landscape – for creating abstractions:

- Simplify the subject and leave out details.
- Leave out all aspects of depth, such as shadows and perspective, and purposely return to a two-dimensional depiction.
- Simplify the shape by stylising it using rigid, irregular or jagged lines.
- Change the colours on purpose to non-realistic ones.
- Reduce the whole composition into a number of principle lines and shapes.
- Create our own unusual or unnatural composition.
- Draw just the outlines of shapes and transparently superimpose them.
- Draw the subject using alternative line techniques.
- Use a different, unnatural texture.
- Elaborate the subject using another, more abstract style.

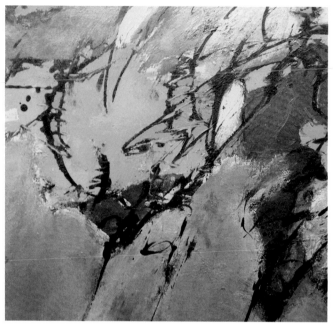

Shape study.

In the end, so little will remain of the initial reality that you can easily separate the subject from its function. You will therefore have reduced reality to abstract shapes to be used in your study or painting. Now there will be nothing in your work that could suggest the reality from which you started. The extent to which you carry out this process will determine whether your work is considered as something recognisable or as being abstract. The further you move from reality and the closer you approach total abstraction, the more individual touches you will add and the greater the space you will allow for expressing your artistic ability. Therefore even if you are a figurative painter, you too will benefit from working with abstract techniques.

From abstract to figurative

So, by means of abstraction we work from the figurative to the abstract. But as an abstract painter we also have the freedom to work the other way around, in other words from the abstract to the figurative. In this case we usually begin by experimenting. Simply playing with materials and techniques is the most free and relaxing way we can start. When, at any given point, we have created something recognisable, i.e. something that can be named, then we can decide to develop this further by making it even more recognisable. To be able to do this in a convincing manner, figurative knowledge is particularly important. To develop this knowledge, you will need to practise your drawing skills.

The Abstract Painting Method

The Abstract Painting Method is a new way to study. Using this method you will become familiar with the working methods and tools used by abstract painters. The method will guide you towards free and expressive painting. It will teach you how to work from within, drawing on your own feelings and artistic ability, and it emphasises originality and individual style, which are the unmistakable foundations of all true and artistic expression. In the Abstract Painting Method you will learn how to deal consciously with the foundations – the building blocks of all the works you will create.

The building blocks of a painting
What do we need to create a painting? Naturally we use paints and brushes, but there are other things in the painter's toolbox, namely our picture language, or the elements that we bring to our canvas. We can divide these roughly into primary and secondary picture elements. The primary elements are the more direct materials, or ingredients, that we can use to build up the indirect, secondary elements. We can identify the following picture elements:

Primary picture elements: line, shape, colour, tone, format and texture.
Secondary picture elements: motion and dynamism, pattern, rhythm and repetition, equilibrium and balance, unity and harmony, variation and gradation, dominance and emphasis, contrast and opposition, dimension and depth, space and plane division.

The composition
The primary and secondary elements come together in the composition. Every painting is a repeated classification, arrangement, amalgamation or composition of components of all of these elements. This is the case for both figurative and abstract painters. Additionally, figurative painters can hold on to the details of reality. This is an advantage that the abstract painter does not have. All that the abstract painter has to grip on to are the picture elements. It therefore makes sense to become familiar with them.

Starting point
The Abstract Painting Method is based on the picture elements defined earlier as the starting point of the learning programme. In this way we will learn to recognise and apply our picture language. Along the way we will develop our artistic skills (feeling for colour, shape, contrast, composition, etc.) and over time we will use these artistic sensory sources in a completely free and intuitive manner.

Skills
In order to learn how to paint expressively, we need to be able to master:

- Technical skills
- Painting-related skills
- Artistic skills
- The ability to express ourselves

These are the forces behind the artistic process, irrespective of style. The Abstract Painting Method stresses the activation, development and growth of artistic skills – our internal sources of feelings that

drive the spontaneous, intuitive painting process. The following are essential to this type of painting process: **creativity**, **expression**, **originality** and **individuality**. These four qualities are key to creating art. That is why they are the goals of the Abstract Painting Method. Anyone who is enthusiastic about freestyle painting will also have to focus on these qualities. In other words, your main goal is not to create a magnificent work of art but to develop the qualities and skills mentioned above. This is the necessary condition for being able to create 'art' in the long term.

Abstract methods for everyone

If you follow the Abstract Painting Method, it does not mean that you only have to paint abstractly – just the opposite in fact. The methods and the exercises contained in this book are only intended to develop your artistic abilities, your feeling for colour, shape, texture, composition, harmony and so on. Above all, the abstract method will stimulate you into getting in touch with figurative reality in an experimental and expressive way so that you will be able to create something individual and unique. And this certainly also applies if you are a figurative painter.

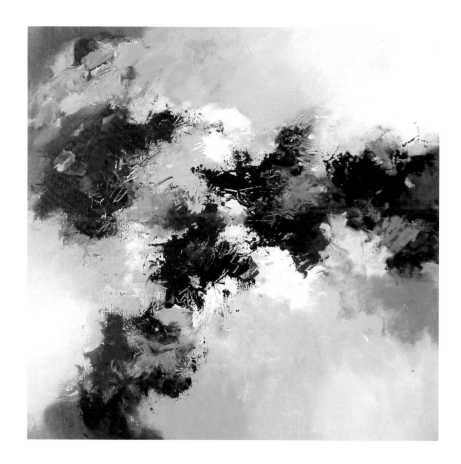

Acrylic on canvas, 70 × 70cm (27½ × 27½in), by R. van Vliet.

2 'What' and 'how'

Whatever your style, you will always start out with the questions: 'What am I going to paint?' and 'How am I going to paint it?' So you are an enthusiastic painter and are champing at the bit to get going with your brushes and paints. Everything is prepared, your canvas is on the easel, and the paint, brushes and knives are all waiting. Everything is ready to go. But are you ready to start too? Do you already know what you are going to paint? Or are you the type of person who dips their brush into the paint pot and attacks the canvas without any real thought or intention? There is nothing wrong with this – go right ahead, at least you have no problems in starting. But not everyone is able to start from scratch in this way. Most people only start painting when they know what they are going to paint. The figurative painters among us will then choose between a landscape, portrait or still life. Choosing the subject for a painting in advance makes what we will do later a lot clearer. We then already know more or less what the composition is going to look like, which shapes we are going to draw and the colours that work well with these. All in all, this gives us a sound starting point to the painting session we are about to begin. The story is a little different for abstract painters because they do not paint a defined, recognisable idea or something from reality. Therefore they have to invent everything for themselves, from the shape and composition to the colour and texture.

Nevertheless, before beginning, the abstract painter will also have to answer the following questions: 'What am I going to paint?', 'What is my composition going to look like?' and 'Which shapes, techniques or colours am I going to use?' If, as a painter, you are able to answer some of these questions in advance, you will have a good foundation on which to begin.

Abstract subject

We often make the mistake of thinking that we should paint 'something' and that we should be able to name this 'thing' and also that it should represent something. For the abstract painter however, it is already enough when that 'something' is related to the picture elements, the technique, composition or style. In short, these are the painting elements that we use to build up our work and to depict thoughts, feelings or emotions. Even when we use real objects as the subject of our painting, we will be primarily concerned with the abstract qualities of the object. So we are not just going to depict water, for instance, but primarily the shapes, lines, rhythms, colours or textures that we observe in it. In other words, the subject of our painting consists mainly of abstract details.

Learning to see abstractly

When it is clear that abstract painters are mainly inspired by picture elements, then it is a good idea to start by dealing specifically with these elements. In this way we will learn to observe for ourselves based on these elements. In order to learn to 'see', we need to develop a particular sensitivity and skill. Therefore we will not focus on shapes or ideas that can be named, but instead we will look for abstract values that will form the basis of our painting. We will open ourselves to discovering shapes, lines, rhythms, colours, plane divisions and so on. Therefore we will make our observations on the basis of the picture elements that not only form a painting, but which also, in fact, form everything that exists around us. After all, even a coffee pot has its own particular shape, colour, tone and format. A landscape can be divided into shapes, colours, textures, lines and so forth. For example, how often are we attracted to the splendid colours of a sunset or the unusual architectural design of a bridge? Each of these draws our attention to the picture elements. When we are able to observe in this way, which is second nature to many painters, then the question 'What shall I paint?' becomes very easy to answer. So learn how to 'see' and you will discover that the world is a rich source of ideas.

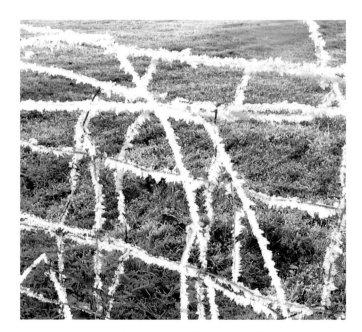

We can use shapes and lines from reality as the starting point for a plane division and/or a line or shape composition.

3 Creating ideas and concepts

Input – internal process – output

The development of an idea for a painting is a process that moves from an input via an internal process to an output. As painters, we are very receptive to external influences. We receive thousands of stimuli (input) through our senses. We mentally process these impressions into ideas, whether or not they are useful. In our thoughts we play with the material we have received (internal process). We sort our impressions, send many to the bin and eventually concentrate on a number of useful thoughts, which we can develop into a more structured idea: the concept. As soon as the concept is strong enough, we continue by picking up our brush to create and visualise the concept (output).

This process, from input via an internal process to output, is the mental process that precedes every painting activity. It is the process by which we find answers to the question: 'What shall I paint and how?' In this process we design the blueprints, as it were, which can then be used to guide the painting process. Therefore it is clear that the mental preparatory stage for a painter is at least as important as skill with using materials and techniques. An input–output process that is intense and rich in images can make many contributions to the final concept.

Internal image

The internal process strengthens our ideas so that we create a certain depiction of it. We create, as it were, an image in our mind, an internal picture. We 'see' more or less where we want to go. We are then in a good position to start. We can compare this to the stage at which a figurative painter has arranged his subject in front of him. In other words, the support that the figurative painter finds in the external, visual and visible still life is the same as the support that the abstract painter finds in the internally formed image. Furthermore the figurative painter will remain closer to reality (external visual facts). The abstract painter, on the other hand, will allow himself to be guided by feelings, expression and intuition (internal mental feeling).

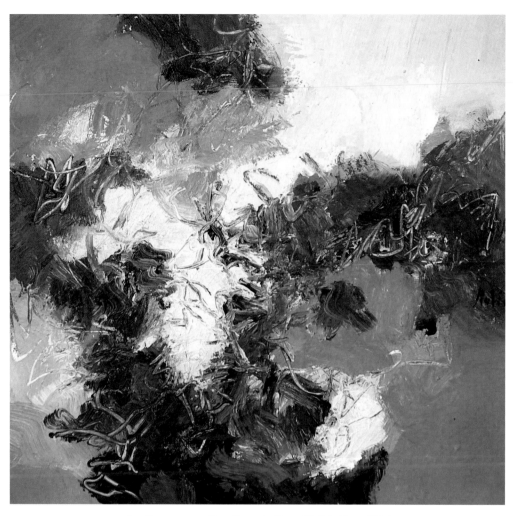

Acrylic on canvas, 60 × 60cm (23½ × 23½in), by R. van Vliet.

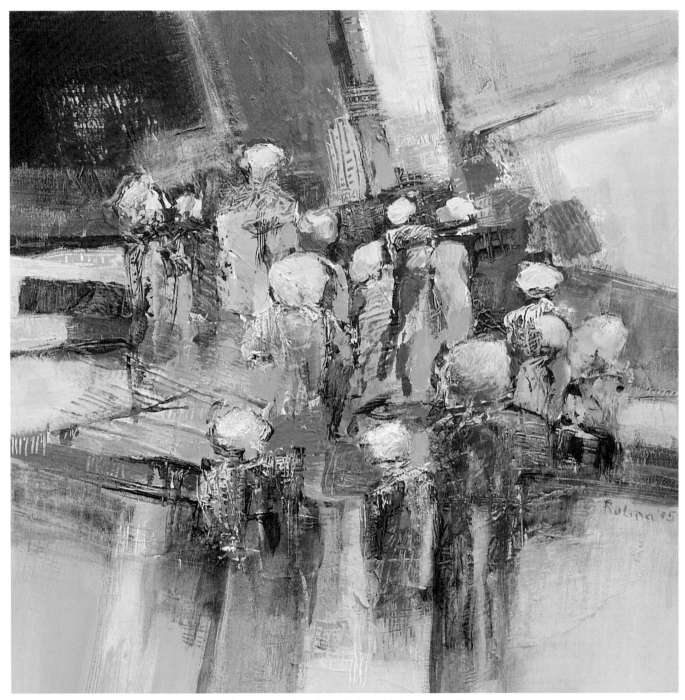

Acrylic on canvas, 60 × 60cm (23½ × 23½in), by R. van Vliet.

Conceptualisation

When our thoughts and ideas form a concept, as in the process described above, we are essentially ready to begin. Whether that concept is already fully elaborated or is just a vague image we have conjured up is another story. One needs only a simple plane division or colour combination, the other preferably starts with an elaborated design. To be able to guide the free, intuitive process properly, it is important that we provide our concept with as much information as possible. The firmer our idea (internal image), the more intensely we can instinctively guide the painting process. When developing a strong internal image, we should consider the following aspects:

- **The basic thought** This springs from a feeling, a memory, an idea, an object or simply the need to go and paint.
- **Colour** Which colour combination fits instinctively with the idea behind the painting? Are the colours light or dark? Are you going to choose contrast or superimposed tones, monochrome or analogous colours? In other words, what colour scheme are you going to choose?
- **Line** Do lines play an important part in the work – in the plane division, for instance? Or do lines appear in the image as outlines, textures, rhythms or emphasis?
- **Shape** Do you want to use shapes or will your painting be shapeless? Are the shapes derived from reality and are you going to abstract these? Perhaps they will be undefined, free, abstract shapes. Are you going to choose rounded or angular, irregular or smooth shapes?

- **Texture** What texture techniques are you going to use? Is the texture solely a visual element or is it also tactile (it can be felt)? Is it quite smooth or are you going to use relief? Do you need to add any other materials? Are you going to use collage? What needs to be done to achieve certain effects?
- **Composition** What type of composition are you going to use? Will it have a focal point or will it be without focus? Are you going to use passive and active areas and where will you place them? Are there lines that lead in and out of the image? What does the plane division look like?
- **Work sequence** Does your idea require a preliminary study or underpainting? Should the texture be applied in advance or at a later stage? What are you going to begin with and what will come next?
- **Style** Is the style completely abstract or should you still be able to recognise something? Does it have an expressive appearance or are you going to choose a structural, straight, smooth and uniform style? Are you going to use a spontaneous or a methodical approach?

In short, there is a whole series of considerations that can underpin the internal image of your concept. Some painters brood on an idea for days on end and only begin working when they have a sufficiently vivid internal image. This is an instinctive process for every painter and partly depends on talent, knowledge, experience and artistic ability.

4 Sources of inspiration

Inspiration is the stimulus, the energy and the impulse to act. This is something we cannot live without as artists. It nourishes the painting process. Often inspiration will be the motivation behind our painting. To become inspired we need to be open, sensitive and receptive; our mind needs to leave the door wide open to inspiration. The more receptive you are, the more easily you will become inspired. Naturally this also depends in part on your mood and feelings. There are a large number of sources from which we can draw inspiration. For the sake of convenience, we can divide these into painting-related, visual, mental and auditory sources. Nearly everything that inspires us fits into one of these categories.

Painting-related sources

These involve aspects such as style, picture elements, composition, technique, materials, organisation of work and everything that is directly related to the painting process.

Visual sources

Visible aspects in particular will play a special role here. It goes without saying that this category is a more direct source of inspiration for painters who are highly visually orientated. These sources are easier to manipulate than non-visible sources, which generally require greater empathy.

Mental sources

Here we can consider thoughts, memories, feelings, perceptions, meaning and emotion.

Auditory sources

These sources point to aspects such as noise, music, sound, tone, pitch, melody, rhythm, cadence and so on.

PAINT URCES

As r e much thought to these at
fi· s want to be painting 'something'
 usually has a name and a general
 landscape, portrait, flower and so on.
 ɔu have mastered the Abstract Painting
 .ve learnt to work with it, you will also
 .at the 'something' can be represented
 elements, composition and other painting-
 spects. They form the basis for many painting
ιɯ .nd concepts.

Among the painting-related sources of inspiration, we can include the following:

1 Primary and secondary picture elements
2 Composition
3 Technique and material
4 Style
5 Stages involved with the work and design
6 Theme

For more detailed and specific information about picture elements, composition and other painting-related sources, see *The Art of Abstract Painting* and *Painting Abstracts: Ideas, Projects and Techniques.*

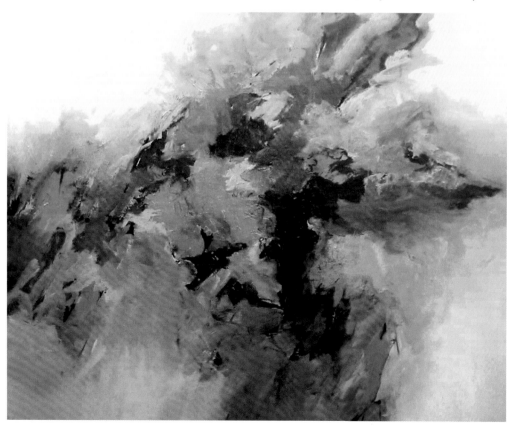

Acrylic on canvas, 100 × 120cm (39½ × 47¼in), by R. van Vliet.

Primary picture elements

Line

Lines are purely abstract details. We create this element and it functions merely as a drawing tool, allowing us to represent shapes, plane divisions and linear effects on a two-dimensional surface. When we use a line to create a plane division, it serves merely as an aid to creating a composition. However, as soon as we start using lines expressively, they play a more artistic role and influence the whole appearance of our work. Lines are also a means of achieving other picture elements. Linear actions can create texture, direction, dimension, depth, dynamism and movement in a large number of ways. Lines can divide up the picture plane but can also provide cohesion, unity and harmony. They can exude equilibrium and tranquillity and can play a role in creating variation, rhythm, pattern, emphasis and contrast.

Line representing spontaneity.

Types of lines

Lines can be added using many different materials and techniques. We can group them according to how they are created:

Linear actions Each linear action produces a picture symbol, which we can call a line or stripe irrespective of its colour, length, thickness or the way it is created.

Linear effects Lines or stripes can also exist without any linear action. There are a large number of techniques that produce line-type effects such as printing, blowing, paint-flow, stencilling, dripping and pouring techniques.

Line variation and handwriting

Lines can be thick, thin, defined, blurred, angular, curved, faint, dynamic, static, strong, hesitant, tentative, straight, descriptive, broken or continuous. It is extremely important here to practise using spontaneity in order to liven up a dull, monotone, mechanical line style. It is here that the line finally starts to follow an expressive path. Spontaneously and intuitively, lines eventually become the painter's handwriting and in this way a reflection of the character, nature, mood and feelings of the artist.

Shape

The picture element 'shape' makes us think of the following:

- Abstract shapes that cannot be named.
- Nameable shapes from reality.

The language of abstract shapes

When you dare to create a completely abstract painting, you will use a depiction-free shape language that we can roughly divide into four groups:

Geometric shapes are squares, rectangles, circles and other similar shapes. These are the basis for geometric abstract art forms such as constructivism.

Symbolic shapes are symbols that have a decorative function and have a partial connection with meaning. We mainly see these elements in cultures in which not only art but also clothing, homes and utensils are decorated in traditional symbolic shapes.

Organic shapes are free shapes that are present in nature and are used abstractly. We can find organic shapes in rock formations, stones, microscopic organisms, clouds, moulds, etc.

Free shapes are expressive, jagged, variable shapes, which result from spontaneous and experimental painting processes such as abstract expressionism.

Shapes are only interesting when we are able to express our creativity using shape variation. So we can think here about expressive or even structural shapes; torn, cut, open, closed, flat or mouldable shapes (in two dimensions or three dimensions); large shapes or just small, narrow or wide shapes with or without outlines, etc.

Shape vocabulary

Here is a real challenge to enable abstract painters to build up their own shape vocabulary. Buy a folder in which to gather all of the shapes you have ever designed. This will be a part of your own documentation, which you can draw on when you are looking for something a little bit different. It is a fact that variation is an extremely basic tool, which unfortunately is too often neglected.

Lines acting as a frame for displaying shapes.

Colour

The pictorial element 'colour' is a source of inspiration and expression, and as painters we cannot do without it. Particularly in abstract works, nine out of ten times the colour element is the most appealing component. For painters, colour conveys a certain feeling. Colour gives atmosphere and character to our work. It is important to develop our feel for colour fully. Make sure that you know about terms and properties such as **primary**, **secondary**, **tertiary** and **neutral colours**. Furthermore, abstract painters make a lot of use of **analogous**, **monochrome** or **complementary colours**.

Analogous colours are colours that appear next to each other on the colour wheel – red, red-orange and orange, for example. They emphasise aspects such as harmony, unity and tranquillity.

Monochrome colours are variations within one colour family. We have the red, blue, yellow, orange, green and purple families. These give unity and harmony. Have a go at painting with different blues and look for variations and combinations by adding black, white or an adjacent colour to your palette.

Complementary colours are auxiliary colours. A complementary colour is a mixture of the remaining primary colours. So green (yellow and blue) is the complementary colour to red. The complementary colour to yellow is purple (red + blue) and to blue it is orange (red + yellow). Complementary colours either intensify or weaken each other. Complementary areas next to each other enhance the colours. A red area surrounded by green allows the colours to clash and shout at each other. However, when we superimpose complementary colours transparently or as washes, or we mix them together, they knock each other back. The force of the colour is reduced and this makes the colours more neutral. The use of the complementary function is a powerful way of producing colour intensity and colour contrast. For this reason, try to make conscious use of it. Colour also plays a large role in establishing the primary picture element of tone and the secondary picture elements of space, dominance, harmony, unity, rhythm and contrast.

For more detailed information about colours, consult my previous books: *The Art of Abstract Painting* and *Painting Abstracts: Ideas, Projects and Techniques*.

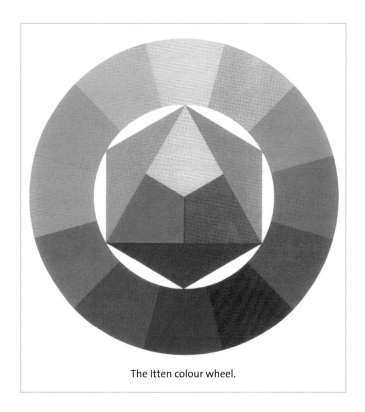

The Itten colour wheel.

Colour schemes

Colour is part of the painter's handwriting. You can recognise many painters by the specific 'palette' or scheme that they use. That is why we have to practise and experiment with colours a lot to achieve our own personal colour scheme. A common mistake made by beginners is to choose too many colours. In expressive painting, we have to realise that our artistic sense regarding colour mainly involves the combinations, mixtures, tonal strengths, softening, hardening, shades and variety that we can achieve using a palette of, at most, two or three colours. We must also look at achieving our own individuality and originality. Many beginners often make the mistake of trying to solve a lack of colour intensity and variation by adding extra colours to their work, which leads to 'incorrect' mixtures and 'dirty' colours. We will have to learn to solve the problem of lack of intensity and variation by making use of tone and contrast and finding shades in the colour scheme we started with.

Choice of colour schemes

Every painter has his or her own favourite colours. However, by using these you run the risk that all of your work will look the same and assume a monotone appearance over time. Therefore try to use variation here too and try another colour scheme, basing your choice on the following options:

- Monochrome scheme
- Complementary scheme
- Analogous scheme
- Primary scheme
- Secondary scheme
- Neutral scheme
- Multicoloured scheme

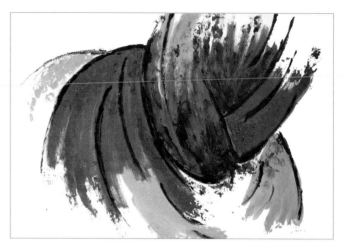

Acrylic on paper, 50 × 60cm (19¾ × 23½in), by D. Engelsman. Primary colour scheme.

- Brown or grey scheme
- A scheme with one dominant colour
- A scheme with two main colours

To explore your colours further, you can opt for a palette with just one colour and use black and white alongside this. You will then focus completely on the possible shades, contrasts and variations of that one colour. This is a fantastic exercise for improving your knowledge of colours. Furthermore you will be faced with the challenge of achieving unity, cohesion and harmony within an extremely restricted colour scheme.

Plan your colours
I always advise my students to choose their colour schemes early on to avoid unpleasant surprises later.

Tone

Tonal intensity and strength determine the power and character of your work. In practice the importance of tone is seriously underestimated. This results in flat, dull and literally monotone work, which lacks any force of expression. It is easy to solve a lack of tonal intensity and variation. In every work you create, train yourself to use a tonal scale of at least three values. Do this for both black-and-white and for colour pieces. Always check your work for light tones, mid tones and dark tones. Make regular tonal studies in pencil or paint using two to five different tonal values to build up experience. We can create a painting in which the light tones are dominant. This is known as a 'high key' effect. If we work mainly with darker tones, then we use the term 'low key'.

Tone plays a role in variation, graduation, unity, harmony, dominance, emphasis, contrast and opposition, as well as in providing focus and areas of attention. Tone also influences the atmosphere and mood that a work projects. Tone varies from hard and impersonal to soft and sensitive. It emphasises the effect of light, whether it is sharp or diffuse. Alongside colour, tonal contrast is our most powerful tool for creating appealing work.

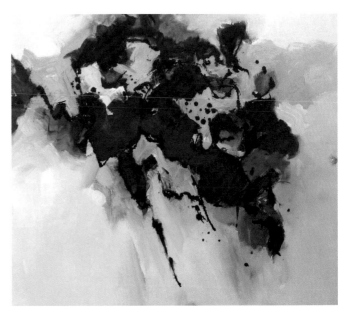

Preparatory study involving colour, tone and format.

Format

We can adjust the format of a picture to the measurements of the support. So you can opt for a large or small picture plane, it can be narrow or wide and use a landscape or portrait orientation. As a pure picture element, however, it involves the format of the shapes that are placed on the picture plane and the scale at which things are depicted. So, for instance, you can show your design at a very small or large scale (micro or macro format). You can also considerably enlarge part of it. Format variation is still underused and therefore deserves greater attention.

Texture

When talking about texture, we are referring to all of the effects that interrupt and break up smooth painting surfaces. These are the various layers with which we build up our work. Texture is everything that we apply under, in and on our layers of paint and in so doing add variation, irregularities, emphasis, relief and roughness to our surface. Therefore texture is a very distinctive, artistic element. It is our personal response to the material and therefore intensifies our originality and individuality. It leads to unexpected, interesting and surprising effects. It provides contrast and dynamism and makes dull areas active, energetic, lively and exciting. It is a huge source of direct inspiration and activates our fantasy, creativity and powers of expression. Texture takes our paintings to a higher level of artistry. When we are able to bring some of that into our work, we are on the right track.

Tactile and visual textures

We can distinguish two types of texture: tactile and visual texture. Tactile texture is visual and can be felt as a relief. A visual texture can be seen but not always actually felt, such as in printing techniques, pencil shading, dripping and pouring techniques and effects using materials such as salt.

Materials and techniques

Texture can be applied using the following:

Materials We can fix and apply materials into and on top of our work, which roughen the surface both visually and to the touch, by using texture pastes, sand, sawdust or collage material, for instance.

Technique Using a brush, knife or other tools, we can add irregularities to our work. Think here about techniques such as scraping, scoring and *sgraffito* (scratching out), pattern stamping, knife techniques and expressive brushwork.

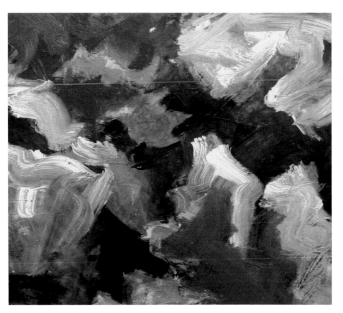

Texture detail showing a brush technique.

Texture time

There are three different stages at which texture can be introduced to the painting process:

- In advance, applied to the canvas as a type of foundation.
- In the paint layer while painting.
- Afterwards, on the sufficiently completed work, to add emphasis and the finishing touch.

Secondary picture elements

Secondary picture elements influence the composition, power and 'voice' of the work. It is important to consider how we create unity in the whole work. Learning to be aware of secondary picture elements can help us to organise the painting.

- **Movement and dynamism** produce liveliness, energy and action. Movement is actually the visual progression from one place to another. It partly determines the path and speed at which our eye explores the painting. It leads the eye in, across and out of the painting. When there is an emphasis on horizontal stripes, this gives a calmer appearance than when the emphasis is in the diagonal direction. Vertical features emphasise stability. Repetition and short rhythmical stress also give a sense of motion because our eyes follow the rhythm and hop from one shape to another.

- **Pattern, rhythm and repetition** indicate shapes, lines and textures that are more or less equally present and, in this way, create rhythmical repetition. They emphasise movement and dynamism but also unity and coherence. Various methods such as printing, scratching out and stencil techniques are very effective for showing rhythm and pattern.

- **Balance and equilibrium** are important to most compositions. Symmetry is the absolute form of equilibrium but it is not very surprising or exciting.

As soon as we deal with different shapes that have also been placed outside the central point, we have to deal with the search for equilibrium. A large, heavy shape positioned on the right requires numerous, lighter shapes on the left (dynamic equilibrium). Balance is not solely a question of the equilibrium of shapes but it also involves tone, colour and texture. Repetition is an essential part of this.

- **Unity and harmony** are excellent ways of bringing order and cohesion to shapes, lines, colours and textures. It requires a lot of experience to develop an intuitive sense of unity. You need to feel that everything has its proper place and that nothing else needs to be added or taken away. Connecting features and repetitions are important for establishing cohesion. There is an art to bringing different elements together so that they appear to the eye as a whole. Similarities between lines, shapes, colours and textures strengthen unity and harmony.

- **Variation and gradation** remind us that a painting needs more than just the same shapes, colours and features. From time to time we need to force ourselves to develop a new visual vocabulary in order to avoid one-sidedness. There is nothing as dull as a work that uses the same brush strokes or structure from beginning to end simply because the artist did not know what it meant to use free and expressive actions.

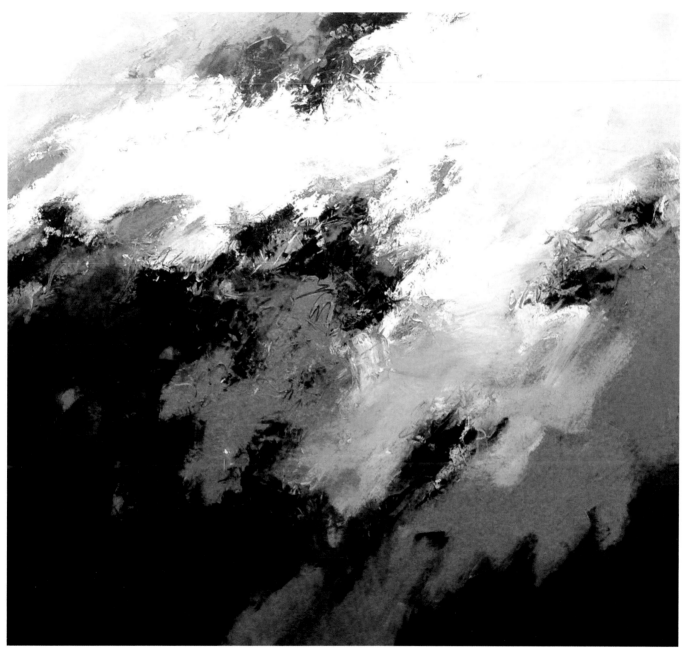

Acrylic on canvas, 100 × 100cm (39½ × 39½in), by R. van Vliet.
Alongside the primary picture elements of colour, shape, tone and texture, various secondary picture elements can be found in this work including dynamism, unity, harmony, variation, gradation, contrast and emphasis.

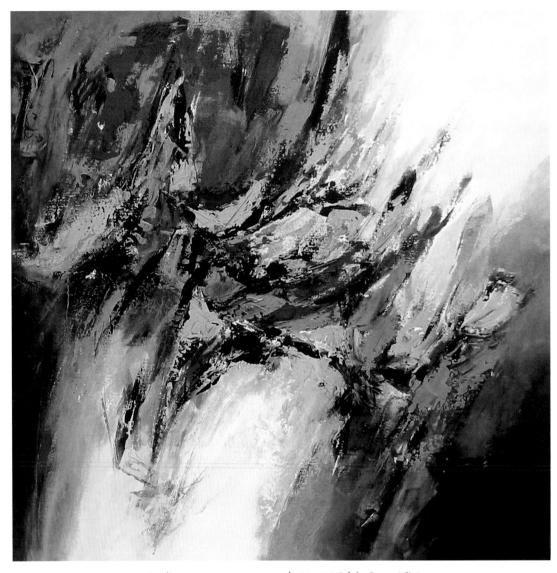

Acrylic on canvas, 100 × 100cm (39½ × 39½in), by R. van Vliet.

You can recognise a number of picture elements in this painting. If you want to explore the many possibilities that picture elements can offer, then it makes particular sense to study your own work and the work of others regularly and then to analyse these based on their picture elements. In so doing you will improve your ability to recognise picture elements and to use them effectively.

- **Dominance and emphasis** are both important. Dominance is instrumental in creating appealing work. It separates the main theme from the secondary theme. It determines what is most important and allows that to dominate by using colour, shape, line and texture. Dominance can involve the focal point. Dominance is also involved when a calm area that does not draw much attention is covered in a dominant colour. Dominance is a tool that helps you to choose what you want to emphasise.

- **Contrast and opposition** often go hand in hand. Contrast is attention, action and tension. You can revive any painting that is flat or monotonous by using contrast. Contrast is the difference between not saying anything and powerful expressiveness. On the other hand, too much contrast leads to restlessness. We need contrast to show our focal point. Contrast is created using the primary picture elements. It attracts attention and cannot be avoided. With contrast we step into a painting, stray away from it and return to it. Contrast is mainly based on a particular opposition such as the difference between large and small, light and dark, many and few, straight and curved, black and white, free and connected, smooth and textured.

- **Dimension and depth** are linked because dimension involves depth. In other words, does our work look two-dimensional or three-dimensional? Is it flat or does it appear to have further depth? To create depth, we can use techniques including geometrical line perspective, format and colour perspective, aerial perspective or overlapping. It goes without saying that when we do not want depth, we should avoid using these effects. Generally, in abstract works we try as far as possible to avoid depth that is connected to the depiction of real objects. Depth effects arising from texture and relief, on the other hand, are suitable.

- **Space and plane division** Depending on the way in which we have divided up our picture plane, our work can give the impression of space. Smaller shapes surrounded by large, empty, free areas suggest ample space, tranquillity and silence. Objects that fill the canvas provide little information about whether there is any further space present. Lines leading us to the end of the picture area suggest further space beyond its edges. Closed shapes and surfaces are shut off from further space. A composition with disconnected shapes gives space to each individual shape but loses cohesion. Shapes that touch each other or overlap dispel the effect of space. Plane divisions can have a lot or very little surrounding space. Furthermore, space can also be depicted as being positive (an object) or negative (the area around an object).

We need rhythm, dynamism, contrast, variation, dominance and emphasis to reinforce the focal point. These give our work extra tension and make it more attractive. Repetition, balance, equilibrium, harmony, unity and cohesion bring tranquillity to our composition.

Composition as a source of inspiration

Composition is the organisation and arrangement of the picture elements that make up our picture language. The composition is the framework and starting point for our painting process. There are various ways of arriving at a composition, from direct and extremely spontaneous methods to carefully thought out, constructed and deliberate techniques. There is an art to arranging everything so that you produce unity, harmony and cohesion from an abundance of elements. A good composition has a particular tension and equilibrium based on a certain level of opposition. Tension is the feeling that something is happening, that a certain action is taking place. Factors such as direction, dynamism, dominance and accent contribute towards this. Before we start to practise, it is useful to pay special attention to matters such as focal point, active and passive areas, plane division and composition types.

Focal point

The focal point is the part of our painting that we want to give the most attention to and which we want to emphasise. This area gains extra emphasis from the way we use lines, shapes, format, colour, tone or texture. That means that we emphasise other elements to a lesser extent. The primary focal point is not an isolated area; it is accompanied by connections and secondary focal points so that a cohesion and unity is created. Lines that enter and leave the image area play an important role here. These lines are purely suggestive; they guide our eyes along to the focal points and other features in our picture. A focal point absolutely requires these lines. Without these lines, our eyes fall abruptly on the strongest points and stay around there. The whole picture then remains outside of our attention. Our focal point is in fact a combination of areas of attention and the entering and exiting lines; it is the signpost for our eyes and shows the direction we should follow visually. You should not see these lines literally as a stripe – on the contrary. Successive emphases of tone, texture, pattern, rhythm, colour and shape can also guide our eyes along a specific path.

In general we do not position our areas of attention centrally, but instead away from the centre of the picture plane.

Primary focus.

Primary and secondary focal points.

Primary and secondary focal points plus entering and exiting lines.

Active and passive areas

A composition gains power when there is a certain interchange between its active and passive areas. We understand active areas as being those in which something is happening, the places that attract our eyes, the focal point(s). This is where we step into the painting and where there is contact with the observer. We can understand the passive areas as places that exude tranquillity. They attract our attention less and by so doing emphasise the active area(s). They quietly give our eyes the space to explore the painting. It is important that you always retain a vision of the painting as a whole. Therefore there should always be a certain amount of contact between the active and passive areas. Note that it is not the intention that you have nothing happening in the passive areas. The passive areas are only 'calm' in relation to the more intense action elsewhere. The active parts tell our story, as it were, and correspond to what we also show as positive shapes. The passive areas, on the other hand, correspond to the surrounding space. This surrounding space is also known as the negative space.

Creating compositions without focus

When we create a work in which there is equally vibrant action across the whole picture, we cannot show one actual focal point. In this type of work, the features that reinforce action are colour, tone, texture, rhythm, emphasis and contrast, and these are applied perfectly evenly across the whole surface. Our attention is then drawn everywhere in equal measure. In abstract painting this choice occurs frequently. Material painters, texture aficionados and constructivists often have a strong preference for compositions that fill the whole picture area with equally distributed intensity.

Plane division and composition types

We usually divide our picture surface when we begin our composition. Based on the location of the active focal point and the main alignment and lines where the action takes place, there are a number of plane divisions and composition types which we can use such as compositions in S, O, Z or H form, L, T, Y, M, N or U form. Furthermore we have the circle, triangle, the symmetrical or asymmetrical composition and the radial, grid, cruciform and frame compositions. The diagonal and horizontal and/or vertical compositions offer further possibilities. You can even use two compositions on top of each other.

Types of composition

Depending on the picture element that is responsible for establishing the plane division, we can begin our work with a form composition (study 9), a line composition (studies 44 and 48) or a colour composition (studies 42, 46 and 50).

Technique and materials

Each of the many techniques and materials used in this book is a source of inspiration. Particularly for abstract painting, technique has an overriding role. Abstract painters can benefit especially from extensive experimentation and research to create original and surprising works. You should see experimentation as a game: just as a child learns and discovers through play, so this is also how it works for a creative person. New materials are being constantly developed. Allow yourself to be inspired. In particular, combine and try out mixed-media techniques. Carry out small studies with these and keep them in your personal folders (see chapter 5). Add an hour's worth of material and techniques every week to your study programme and experience the unrestricted freedom you get from playing with them.

Think of tasks such as the following:

- What can I do with drip-painting techniques?
- How can I combine paint-flow and dot painting techniques?
- What effects can I create with a palette knife?
- How do I work with a paint roller and acrylic paint?
- What can I do with charcoal and oil pastels?
- How do pastel crayons combine with acrylic paint?
- What can I do with tin foil?

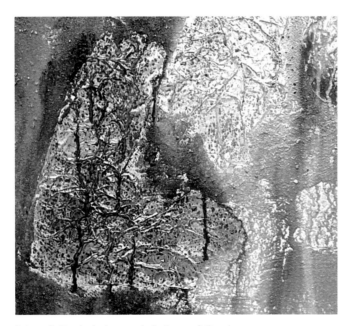

Drip-painting technique and glazing on foil and canvas.

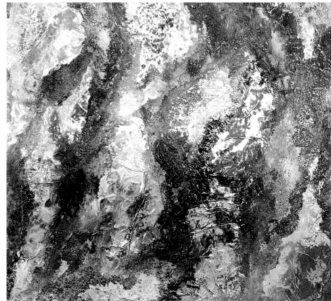

Foil study, by L. van Ooik.

Structuring work

Normally, all you need is a simple concept to start from. There are also concepts and ideas that give us additional information during the painting process; in other words, the path we follow and how we reach our destination. In painting terms, we are talking here about the work structure or sequence of work. Depending on the final image that you have in mind, you may find it necessary to plan certain technical steps in advance in order to create your desired effect. The whole painting process actually consists of many painting stages.

From start to finish

Between starting and finishing, you will carry out many steps, some of which you planned, others you did not. Together they lead to depth and content and are the repercussions of every action that you intend to carry out, leading to the final result. In other words, an intensive painting process that leaves an impression of our character, temperament, mood, engagement, feelings, emotion and artistic sensibility.
The more experience you gain with ordering and structuring work, the more you will take these steps spontaneously. The stages involved in the work will guide the painting process in a specific way and influence the result. Stages vary, from very brief to time-consuming. They can consist of first A then B, or the other way around. But you may also need stages A to D or A to Z. So there are already tens of thousands of ideas ready for you, whenever you make the effort to design them. To illustrate this point, here is a short example:

1 Begin with an underpainting.
2 Create a line sketch to divide the surface.
3 Apply colour to the whole area in an expressive painting style.
And there you are. It couldn't be simpler.
But what happens if we make a simple change?
1 Begin with an underpainting.
2 Freely bring in various colours.
3 Using lines, show features and a clear division of shapes.
By simply changing the sequence, the end result will be totally different.

Style

A great many style periods throughout the history of art are characterised by a defined, specific manner in which the painter wanted to depict ideas on the canvas. Materials and techniques have changed over time and so has the function of painting, as the arrival of photography transformed how reality was depicted. From that point onwards, painters were able to allow themselves greater freedom as their main purpose was no longer to represent reality. This freedom led to many movements including Impressionism, Expressionism, Fauvism, Cubism, Minimalism, Constructivism and Colour Field Painting. As a result, style became a representative and iconic component. In abstract painting, we make a lot of use of the following schools of art:

Constructivism In this style, the creation of a design in advance plays an important role. This mainly involves a composition that has a considered and balanced structure in which the form language is derived from geometry. This style principally uses pure and unmixed colours and no textures.

Expressionism This style mainly adopts a spontaneous, intuitive approach. Here more use is made of free shapes and structures.

Lyrical abstraction Works in which extensive abstraction is applied to mainly figurative shapes from reality but that remain recognisable.

Non-figurative art Completely abstract work built up from unnameable, free or geometrical shapes. Shape, line, colour, texture and subject matter all play key parts in this.

Cubism Brings the shapes back to the flat plane and transforms everything into square, blocky shapes.

Colour Field Painting This emphasises large, empty colour areas with nothing to be seen apart from texture and colour.

Material painting This style mainly involves a layered composition, generally incorporating heavy fillers, objects and other materials into the painting.

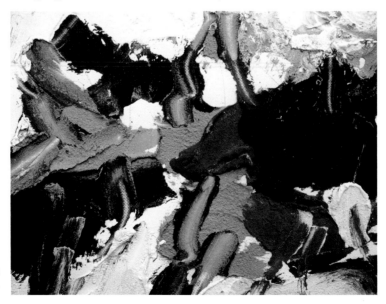

Detail from a material painting.

Theme

When we choose to use a theme as a starting point, it is best to research our theme thoroughly first. Analyse it, brainstorm and gather image materials to nourish your theme. You have to understand that by going deeper into your theme, you can find extra inspiration to develop new concepts. In the art world, we often come across painters who base all their work on one single theme. You do not have to link everything to the same theme now, but it would be a nice challenge when using a theme to opt for at least ten variants. Therefore always try to look at your subject from different angles. Here is an example to illustrate this.

Imagine that your theme is 'the newspaper'. What could you do with this?

- Emphasise the meaning of a text and visualise this on your canvas.
- Use a certain photograph purely as a basis for dividing planes.
- Use newspaper photographs only as collage material (study 27).
- Use a photograph to create an expressive elaboration (study 12).
- Use a photograph to abstract into an abstract image.
- Use the crumpled paper as a tactile layer of texture on your canvas.
- Use the printed letters as a visual, rhythmical texture layer.
- Cut out individual letters and use them to create your own texts.
- Use the same individual letters to give your work a rhythmical pattern (study 33).
- Cut or tear out a variety of shapes from the newspaper and use these as collage material or to make a template.
- Design your own newspaper page.
- Use the layout of the newspaper as a plane division.
- Use a ball of newspaper to stamp on patterns or to brush on paint.

We can go on and on. This shows that going deeper into a theme leads us to grow in terms of the painting, creativity and inventiveness. Naturally you can also extend your theme into a series by using different techniques, colours, materials or styles. In short, there is a lot you can do to develop the theme of your painting.

VISUAL SOURCES

As painters, we are very visually orientated people and that is why we become so easily inspired by visible reality; we create ideas from external information. This reality can be:

- **Visually present** The object is physically in front of us (portrait or still life) or we are actually within it (landscape). In general we tend to bring everything that we see on to the canvas. We do not even need to give much thought to this. The visible image tells us exactly what we need to do in terms of shape, colour, texture and so on. In this case, the painting process is driven by external factors.

- **Visible on an image** When working from an image, the external information has already been marked out. Furthermore it has already been represented on a flat surface, making it easier for us to transfer. The process guiding us from the external information is generally robust and it is difficult to free ourselves from this. The advantage is that the painting process knows exactly where it needs to go to. The disadvantage is that there is little room for free expression. But it is just a matter of preference. What kinds of things do we find in reality?

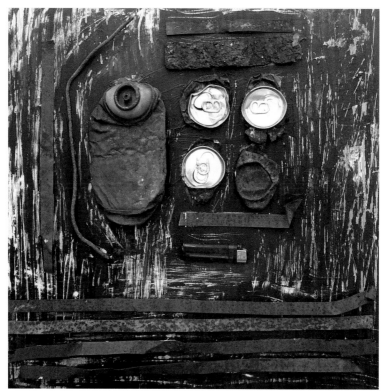

Collage with found objects on wood, 50 × 50cm (19¾ × 19¾in), by M. V. Woudenberg.

Concrete shapes and objects

As abstract painters, our aim is not to paint visual reality in a style that is faithful to nature. That is why we make use of the abstract qualities which reality offers us. In addition to showing a part of reality, we can also incorporate that same reality in the form of objects in our painting. Think here in particular about so-called 'found objects'. These could be anything that we find in our surroundings, which by virtue of their shape, colour and texture are worth being brought into or on to our work as a part of our picture language. Found objects form part of the surface of our artwork and represent picture elements such as line, shape, colour and texture.

Works of art

As art lovers, we naturally come into contact with art created by other people through exhibitions and literature. It is fairly common for us to be inspired by the work of a certain artist or by a certain style. Throughout the history of art, we come across painters who allowed themselves to be inspired by one of their contemporaries or predecessors. So it is impossible to imagine the art world without works inspired by other works of art. When we are inspired by other people's work or by our own work, it makes sense to analyse what it is that we find inspiring about that work. For abstract painters this often seems to be colour. Of course, there are more things, and in addition to colour we are often inspired by composition, plane divisions and textures, shapes or ideas. We often forget this, but it is a fact that our own work can also be extremely inspiring. Furthermore it makes us think of using new effects with a different technique, style, composition, colour or texture. When you allow yourself to be inspired by other people's work, you can make use of this in many different ways.

Technical learning object

When we copy work as best as we can, we do this because we want to learn how and in which ways similar works can be achieved. We analyse the way of working and, based on our technical knowledge and experience, try to create the work. Obviously you can never present such a study as your own work and you must always give it the title: 'Study based on a work by…'.

Expanding your self-expression

You can also use work made by other people to stimulate your own creativity. I always advise my students who begin this way to use inspirational work only at the input stage. Look at it, analyse it, study it and then put it away. Close your eyes and let the internal process do its work. Concentrate and allow your imagination and feelings to come up with something new and surprising. Use other people's work only as a trigger and continue on your own. Search for inspiration in 'the paintings and techniques of Van Gogh', 'the forms of Matisse' or the 'trees of Mondrian', for instance. As a rule, you should present any such work as follows: 'Inspired by…'.

Images

When we are using inspiring, figurative sources, reality can be visible and concrete but it can also take the form of a photograph or illustration. This is a fairly easy way to collect reference material. However, it is important that you do not collect other people's photographs but instead use your own camera. This will guarantee individuality and originality every time. Moreover you need to realise that abstract photography is particularly important for you.

Abstract photography

When we talk about photographs, as abstract painters we are generally not dealing with the idea but rather the images of the abstract qualities that we recognise in reality, such as those we highlighted earlier when learning 'to see' (chapter 2). In other words, even as a photographer you need to learn to see which scenes and phenomena draw attention purely on the basis of their picture elements or composition. Therefore in nature or our surroundings we look for shapes, patterns, rhythms, colour combinations, plane divisions and lines that

will inspire us to develop them on the canvas. So do not photograph a fence, but rather a lattice division and the rhythm of the posts and planks; do not photograph the sunset because of the sun itself but rather because of the distribution of colours and shades. In this way you can fill a fantastic folder with the theme 'Reality seen abstractly'. Think about photographing colours, textures, cracks, stains and patterns in things such as walls, rocks, ice, sand and earth; discover the rhythms and forms in clouds, skies, foliage, buildings, boats or flowers; see the shapes of fish, birds or groups of people and the interplay of lines in landscapes, trees, harbours or architecture.

Figurative photography

Naturally you will probably have a large number of photographs, as everyone does, which were taken with another purpose in mind, namely to capture family or holiday memories. Without realising it, you therefore have a huge source of personal material to hand from which you can gain a lot when you use it as a subject for

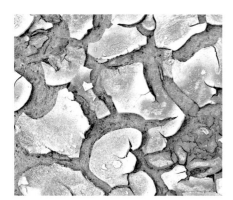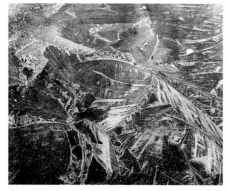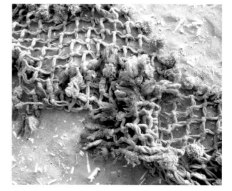

Examples of abstract photography.

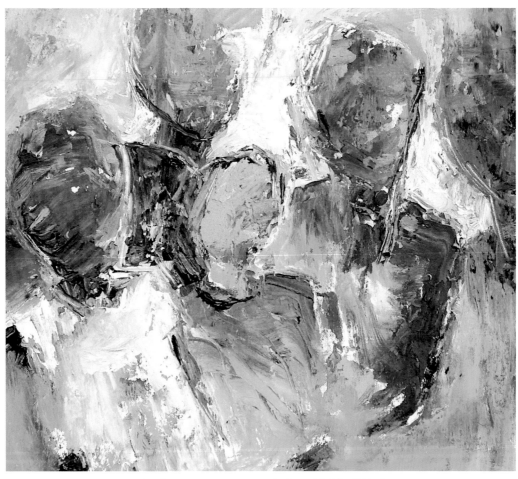

Acrylic on canvas, 50 × 50cm (19¾ × 19¾in), by H. Kool.
Family portrait.

your sketches. You can build up complete projects this way around themes such as family, daily life, holidays, nature and animals or cities and villages. In short, all of the sorts of things you have taken snapshots of. You can also expand this photographic material using photographs from newspapers or magazines.

Photographs of your own work

To finish this section on images, we cannot forget to mention an album containing your own work. I strongly advise that you continue taking photographs of your own work. This is not only to keep track of your development but most of all because your own work can also be extremely inspiring.

Drawing and sketching

We record a large proportion of our observations in the form of drawings or sketches, which are an essential visual source of inspiration even for the abstract painter. Therefore it is very important that you regularly practise drawing and sketching. You can strengthen your picture language considerably from reality when you create detailed sketches of objects or ideas. By doing this you will learn about the shapes and details of your subjects so that over time you will be able to draw them using your memory and powers of imagination. This is definitely important for abstract painters because we prefer to work from an internal image to stimulate spontaneity, originality and expression.

When drawing, we often think of a more detailed, realistic depiction than when painting. When we sketch a subject, it seems that we have more freedom regarding our technique and the results, so we work more on the personal touches and depiction. Therefore in abstract painting, there is a preference for sketching.

An artist's handwriting

Drawing is also essential in creating your own personal 'handwriting'. The way in which you develop your line style, in particular, determines the character of your work. Drawing influences our line style to such an extent that over time we can talk about a personal style. The same line style will also be visible in the way we use paints and brushes. It can even lead to a fully 'drawn' painting, as can be seen in the image opposite (see also study 28).

Variation and expansion

When you do not restrict your drawing sessions to studying the subject, but also vary your techniques and materials, then drawing becomes a true challenge with an extremely practical aim even for abstract painters, namely to refresh your own technical and mental internal resources. This is an extremely personal source of inspiration.

Computer design

If you have a drawing program and/or photo-editing program on your computer, then you have a fantastic means at your disposal of creating endless designs, sketches, colour divisions, plane divisions, shape designs and so on. If you take this a step further then you can also transform and alter your photographic material (your own work if possible) and add extra textures, colours and features. Save your designs and your computer will become a source of visual inspiration too.

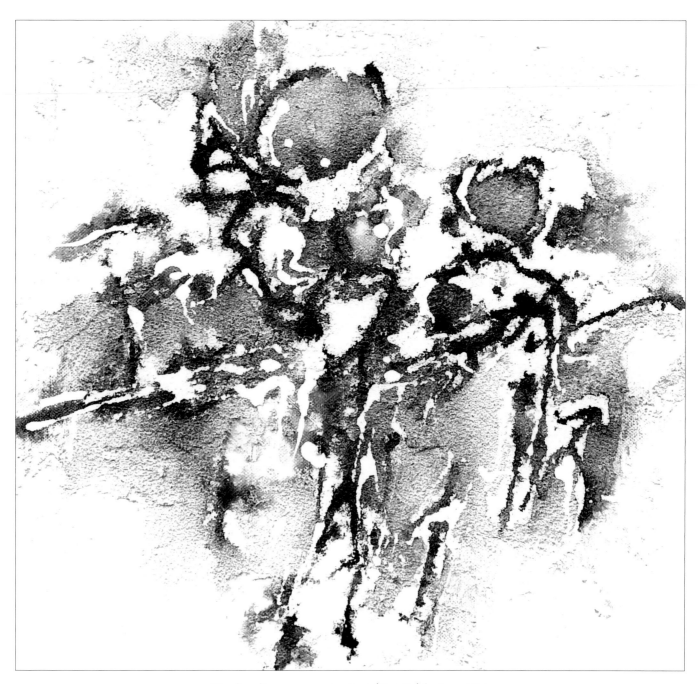

Mixed media on canvas, 40 × 40cm (16 × 16in), by R. van Vliet.

MENTAL SOURCES

These involve everything that encompasses our spirit – emotions, engagement, feelings, ideas, thoughts, experiences, perceptions, moods, memories, imaginative powers, etc.

We are dealing with a very different area from that which we talked about under the heading of 'visual sources'. A visual source is more distant from us. It is an external source, which gives information to us. On the other hand, with mental sources, we are dealing with the most personal, internal information – with impressions that we have made into part of ourselves. Inspiration from mental sources has already passed through a great deal of internal processing. We can distinguish between the following main groups:

Feeling

As abstract painters, we are almost always painting from internal information and therefore from the inside, so we always work with our feelings. We paint intuitively from our artistic sources – our feel for colour, form, texture, composition and so on. This is how the great majority of abstract work comes into being. Incidentally, that feeling is always partly determined by the nature, character and mood of the painter. With instinctive painting, your personality plays a substantial role.

Emotion

If we want to bring emotions into the frame, then that will demand a lot from us. We should be able to have high levels of expression at our disposal. Furthermore there should certainly be actual engagement. Without that depth, we will not be capable of portraying our ideas in a convincing manner. Not everyone is capable of expressing his or her emotion.

Meaning

We are also often inspired by words and ideas, poems or texts from newspapers or books. Words and text are always coupled to a specific meaning. This meaning can evoke images inside us. In this way a transition takes place from word or text via a generally applicable meaning to a personal, visual image, as a concept for our work. The more we brainstorm about a certain idea, word or text, the better the possibility of rendering it as an image.

Memory

Everything that we have seen, felt, heard, experienced or lived through has been stored away in our memory. As painters, we draw extensively on this collection of information. It really comes in handy for us when we want to paint something that is not visible at a particular moment. You then resort to your powers of imagination, where the thing you want to paint acquires form, as it were, and comes into your mind's eye. We are then painting from internal information. A very large number of painters work using internal information.

Even figurative painters from time to time intentionally choose to paint from their mind's eye because it seems to give an even more personal view on things. Often details that do not add anything become faint. Furthermore, painting from internal information allows us to transform the information more easily or change it into other, new ideas. In short, we feel less bound to the chosen object and tend towards a freer, more personal and original interpretation.

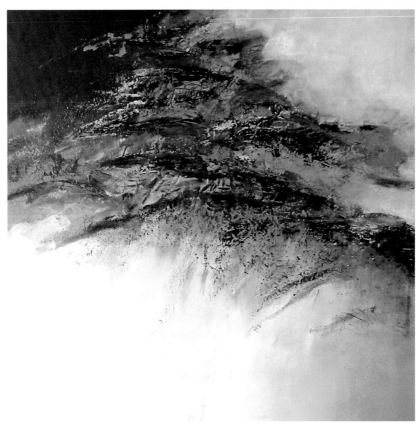

Acrylic on canvas, 70 × 70cm (27½ × 27½in) by R. van Vliet.
Memory of a coastal landscape.

AUDITORY SOURCES

Words and text are means of communication. As painters, we have chosen another medium, namely to convey our ideas and feelings through images. It is not easy to convert from one form of communication to another. Apart from the use of text, meaning, feeling and emotion, we see the same transformation process occur when we make use of sound and music as representations of images. Even audible information is a source of inspiration for many painters.

For a lot of us, listening to particular music is connected with a certain feeling; a certain atmosphere and state of mind. Many painters listen to music while painting because it inspires and stimulates the act of painting. In this sense, music can be seen as a factor for helping the creative painting process. But there is much more to music: it can touch us in ways that inspire us immediately to create an artistic work.

> **Musical inspiration**
> Listening to auditory sources, we can also think of other visual images such as an orchestra, choir, conductor, band or musical instrument (study 49). Concepts such as rhythm, tone, measure, cadence, sound, melody, tempo and also musical terms or notation are capable of unleashing something within us.

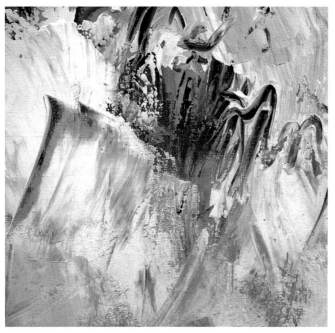

Study in acrylic to illustrate auditory influences such as cadence and overture.

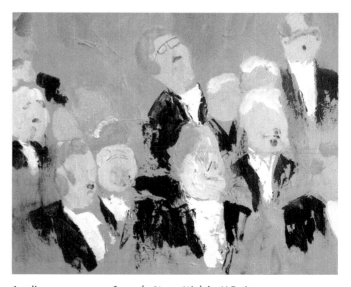

Acrylic on paper, 50 × 60cm (19¾ × 23½in), by H Feringa.

Picturing music

For illustrative purposes, here are a few options to try out:

- Let melody and timing inspire you to create rhythmical, repeated and patterned work.
- Use volume to inspire powerful or, alternatively, weak features on the canvas.
- Use melody and timing to direct your actions. You could try this by using a short introduction to a piece of music as a trigger. The stresses and tempo of the sequence will direct your hand, as it were, and as a result allow longer or shorter line accents or paint strokes to occur in your work. In any case, this is something to experiment with. You will be surprised at what comes out of this. What is special is that your hand is now no longer being guided by internal impulses but rather by audible features that come from outside. This is an interesting experience.
- There is often a tendency to convert sound into colour. The mood and atmosphere of the music instinctively translate into certain colours. The sounds of animals and birds but also the noises of industry, traffic or work activities, for instance, stimulate you to create a particular image. Let the magic happen.

- Listen to songs. These can evoke mood and emotions in which, above all, the meaning of the words can play a role. In this way we are also linking auditory sounds to our mental experiences.
- Listen to the rhythms of a drum as the starting point for a visual, rhythmical image.
- Listen to music and allow the mood and atmosphere of a particular piece to evoke associations and images that ask to be painted (study 24).

Learning to listen

Whatever the method, we are allowing certain effects to stimulate our minds through our senses and to inspire reproduction in the form of an image. Elsewhere in this book I mention that as artists we have to learn 'to see'. I can also say that we should learn how 'to hear' or 'to listen' and in so doing allow another angle from which we can produce artistic expressions. It may be obvious, but even among artists, some have closer connections with auditory stimuli than others. This does not make it any less of an interesting path to explore.

5 Reference materials

In order to become familiar with the general tools of the painter and to gather ideas, you could create folders that contain relevant painting, visual, mental and auditory sources of inspiration. So look in magazines and through photographs for examples of the following, and collect each group in its own ring binder:

- The primary picture elements of line, shape, colour, texture, tone or format; continue with examples of the secondary elements.
- Examples of the many compositional possibilities, plane divisions and designs. By looking for these you will develop your awareness of composition. This is something that will be a huge benefit to you.
- Examples of techniques and materials. Do not forget to store the results from your own experiments in this folder too. Always make sure that you include a description to explain what you have researched.
- Examples of style and other aspects of painting that attract you.
- Abstract photographs you have taken as well as images of your own work.
- Examples of other sources of inspiration and themes from the visual, mental and auditory angles.

Create a special folder in which to note down your own concepts and ideas. You can even include preliminary studies, sketches or designs. Add your own form vocabulary to this.

Remember to record work order, and keep an example of the relevant work sequence in your folder.

Library of reference material
This is how you create your own library of reference material, and by using it you will never be short of inspiring ideas again. In addition, creating these sorts of folders is a very pleasurable and educational activity because, without realising it, you are constantly training your feel for composition, shape, colour, plane division and so on. This is an ideal activity during 'empty' moments when it seems impossible to paint anything, and this method will give you an alternative way of nurturing your studies.

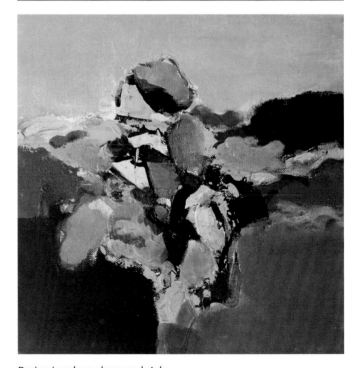

Design in colour, shape and style.

6 Lesson studies

Now that you have read the previous sections, you are ready to start with a series of exercises that I have developed especially for this book. Learning to paint is still purely a matter of practice, so now is the right time to get to work and see what abstract painting can mean for you.

Exercise information
All of the study lessons contain practical, painting-related information and are organised as follows.

- **Study number and the relevant source of inspiration** The title of the exercise describes the source of inspiration, thought or idea, which is the starting point for the task at hand.
- **Study task** Information about the special features that illustrate the aim of the exercise.
- **Materials** This section contains a summary of the tools and materials that you can use to complete the exercise. If you have other ideas you can always change the materials or add extra ones.

- **Picture elements** The most striking picture elements and painting-related concepts are given here in the order in which they appear in the exercise. In this way you will develop a feel for picture language, through learning to recognise and use its components. Incidentally, other elements will nearly always play a part alongside those mentioned, and we cannot let these escape our attention.
- **Technique** Specific techniques used in the exercise are mentioned here.
- **Composition** This describes the principle features of the relevant composition.
- **Work sequence** This is an important part of any exercise. It gives the order of the various stages that you should complete to give your work a specific effect and appearance. Naturally you can make changes to these and follow your own path.
- **Tips** Here you will find any relevant comments to help you.

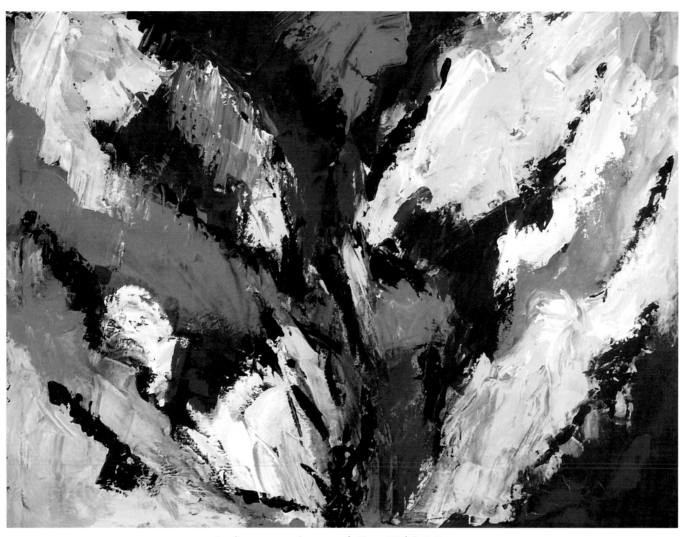

Acrylic on canvas, 60 × 70cm (23½ × 27½in), by L. Bouma.

Images

Each lesson is accompanied by one or more images. You need to see these images as only illustrations of the exercises. It is certainly not the intention that you copy them. In other words, go your own way and complete the exercises solely on the basis of your own feel for colour, shape, composition and so on. I have purposely not used the word 'example' because that would suggest copying. I have used the word 'illustration' because its purpose is to support the text and help you visualise the exercise.

In keeping with the philosophy of the Abstract Painting Method, I should have removed all of the images from this book so as not to influence you beforehand, but a book without images would not be very inspiring. Nevertheless, my students have to manage in general without any illustrations. In this way they are constantly sent on a voyage of discovery. Therefore I strongly advise you to close this book as soon as you begin the exercises and in this way give your own powers of expression a chance.

A large number of the illustrations in this book were made by my students. These were mainly exercises that they carried out during lessons and in workshops. There are also images or details included from several works of art and from short studies especially made for the exercises and demonstrations to illustrate techniques and ways of working.

Practical tips

- The exercises are not arranged in any particular order, by level of difficulty or source of inspiration. You are therefore free to work on any exercise that appeals to you. Choose what you feel like doing and make a start. You will have difficulty with some of the exercises; others will be extremely straightforward and easy.

- The time required for each exercise varies. Some do not require more than half an hour; others may take you perhaps a whole day to complete.

- Techniques and work structure are repeated in other studies, which mainly have different emphases and combinations. By repeating the techniques and stages involved you will become more experienced in the broadest sense. The more you repeat something, the easier it will be to apply it automatically over time. That is what we need to do as expressive painters.

- All the study lessons are intended for practice, so the results do not need to be completed artworks, but rather depictions of your creativity, artistic sense and originality; in other words, the extent to which you as a painter are capable of communicating your message expressively, instinctively and spontaneously through the medium of painting.

- Do not try to follow the exercises too rigidly or see everything as obligatory.

- In these exercises, give yourself the freedom to allow space for your ideas and creativity. In that way you will avoid becoming dependent on tasks created by other people. As independent artists, we ultimately have a duty to develop our own ideas and concepts. When you are able to give your own interpretation to the questions 'what?' and 'how?', you will be on the right path.

Study 1 Expressive painting style

Study task: create a composition in which texture and active, spontaneous painting actions create a distinct effect.
Materials: canvas, board or paper, acrylic paint, brush and palette knife.
Picture elements: colour, texture, tone, contrast, dynamics and harmony.
Techniques: texturing, expressive painting and scratching techniques.
Composition: the composition should fill the whole support. The texture you apply will ensure that the whole image is emphasised. Add a few even, calm, passive areas to give the texture extra force.

Work sequence

1 Apply a coloured underpainting to the main area.
2 Using the brush and knife, add a layer of paint as roughly as possible. Paint spontaneously and instinctively and allow the brush strokes as much movement as possible, leaving some of the underpainting uncovered. Use a colour that contrasts with the underpainting.
3 Bring extra action to the painting by adding scratch marks in the paint while it is still wet. When you do this, the colour of the underpainting below will reappear.

Study tip

To develop an expressive painting style you need to create a number of instinctive, spontaneous pieces in which the movement and stroke directions project action and variation.

Details of an expressive painting style.

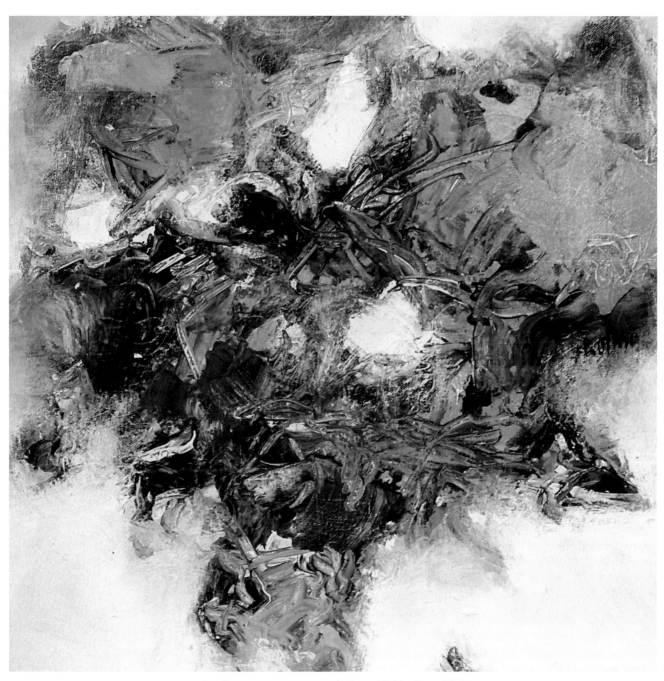

Acrylic on canvas, 50 × 50cm (19¾ × 19¾in), by R. van Vliet.

Study 2 Working from a figure sketch

Study task: use a sketch from a model study as the basis for your composition.
Materials: canvas, board or paper, acrylic paint, charcoal or chalk, Indian ink, fine and medium brushes, gesso, sand and/or texture paste.
Picture elements: line, form, colour, tone, texture, dynamics and harmony.
Techniques: brush and line techniques.
Composition: a design with one or more figures in the central composition.

Work sequence

1 To begin, choose a model study that you previously created or a study directly from life. If you have sufficient experience, create a number of sketches as hand exercises for the spontaneous doodles that you will have to use next to define the image.
2 Work gesso and sprinkled sand into the support on top of the background while wet. You can also add texture paste to several areas if you wish.
3 Allow everything to dry thoroughly.
4 Now doodle on the support using charcoal or chalk. Note: try not to copy the sketches you created earlier because that would take away any spontaneity from your line drawing. Put away the sketches that you made earlier and create your drawing using whichever plane division and shapes you want.

Study tip

It is essential that you draw plenty of real-life sketches of people if you want to be able to depict the human form or a group of people in a free and spontaneous manner. I also advise that you create similar drawing studies regularly because this is a crucial foundation for developing a feel for form. Do not forget that even when drawing spontaneous, distorted or abstracted human forms, these should always be based on an understanding of proportions and anatomy.

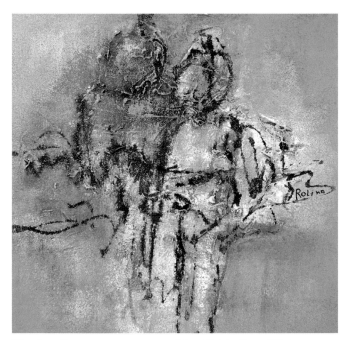

Mixed media on canvas, 40 × 40cm (16 × 16in), by R. van Vliet.

5 Work the colours you choose into the whole area with a brush and paint. Always keep in mind the tone and colour variation.
6 You can emphasise the interplay of the lines if you wish. To do this, use a fine brush and Indian ink. Allow the ink to find its own way on to the paint while it is still wet. This will create a somewhat ragged line style.

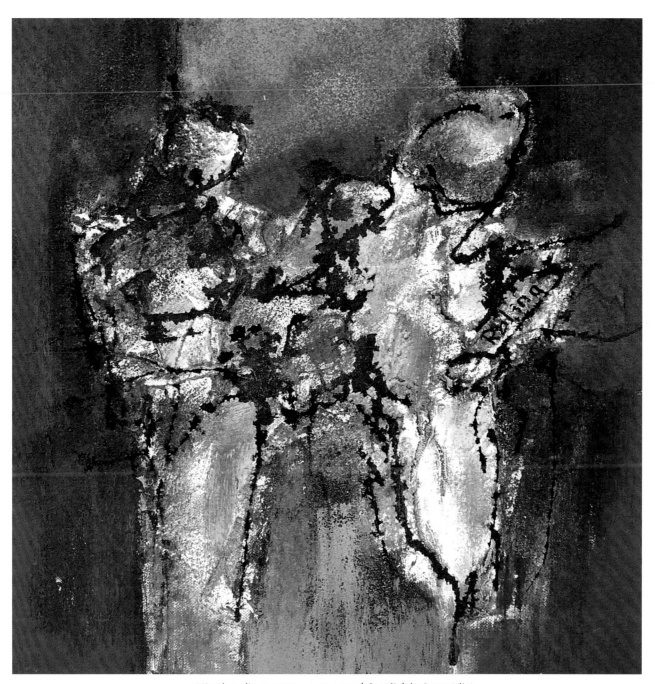

Mixed media on canvas, 40 × 40cm (16 × 16in), by R. van Vliet.

Study 3 Monochrome colour scheme

Study task: create a composition in one dominant colour.
Materials: canvas, board or paper, charcoal, acrylic paint, brush, palette knife and outlining paint.
Picture elements: line, form, colour, texture, format, tone, unity, harmony, equilibrium and balance.
Technique: brushwork, knife-work and contour work.
Composition: create a grid-style, balanced composition using geometric shapes that fill the support.

Work sequence A
1 Begin with an underpainting.
2 Mark out the complete plane division using charcoal.
3 Apply colour to everything.
4 Follow around the features with lines and contrasting colours.

Work sequence B
1 Start with one colour and the palette knife (so no drawing beforehand) by applying rectangular areas of colour to the support.
2 While doing this, use colour combinations to bring some shading and variations to the monochrome scheme.
3 Apply one layer on top of the next and allow the new shapes to emerge spontaneously.
4 Enhance the monochrome image by working in features and contrasting colours.
5 If you wish, you can emphasise the lines by using the line stamp technique or a tube of outlining paint.

Acrylic on canvas, 50 × 60cm (19¾ × 23½in), by R. van de Valk.

Study tip
When we use a monochrome colour scheme, we select only one particular colour. To introduce variations, we can use different colours from the same family on our palette. By also adding black, dark brown or beige to this, we will be able to vary the tones. Whether we decide to use a completely different contrasting colour and playful, decorative, additional line effects ultimately comes down to the personal choice of the painter who, in this way, can make the work spontaneous and unique.

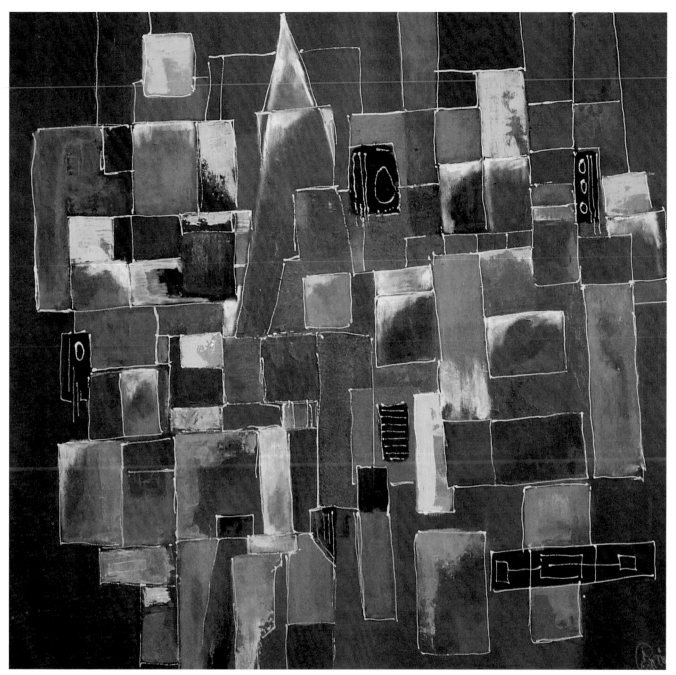

Acrylic on canvas, 80 × 80cm (31½ × 31½in), by C. Goedvolk.

Study 4 Mixed media

Study task: create a study using different materials, which should produce a unique texture.
Materials: canvas or board, acrylic paint, brush, tin foil, card, sand, texture paste, oil pastels and palette knife.
Picture elements: colour, form, texture, tone, unity and harmony.
Techniques: texturing, collage, pastel, glazing, brushwork and incorporation techniques.
Composition: the composition should fill the whole support, without any focal point.

Work sequence
1. Tear out several large and small shapes from the foil or card.
2. Apply a layer of white paint to the board. Press on the foil and/or pieces of card and spread coarse sand on to areas of the paint while still wet. Extra texture can also be added by making score marks in the paint.
3. Allow everything to dry thoroughly and check that the materials are properly fixed down.
4. Glaze the canvas with liquid paint, which will gather in the creases of the foil.
5. Apply another colour to the whole area using undiluted paint and incorporate the materials to create unity and cohesion.
6. You can also add colour features using oil pastels.
7. If preferred, clean away parts of the paint in the areas where you want the foil to shine through.

Pure experimentation

The advantage of experimenting is that you have no fixed idea beforehand, and you are concentrating only on the materials and discovering the effects that can be achieved with them.

Experimentation is nothing but a journey of discovery. It gives you maximum freedom, which is vital to the creative process. The more you allow yourself to experiment, the freer and more creative you will become. Above all it is an extremely relaxing activity because the end result does not have to meet any requirements.

Mixed media using card, charcoal and sand, 30 × 30cm (12 × 12in), by R. van Vliet.

Mixed media using foil and coarse sand, 30 × 30cm (12 × 12in), by R. van Vliet.

Study 5 Impression of an atmosphere

Study task: bring the atmosphere and feeling of a city that has left an impression on you to your painting, or choose a holiday experience as your starting point.
Materials: canvas, board or paper, acrylic paint, brush and palette knife.
Picture elements: line, form, colour, tone, texture, dynamism and harmony.
Techniques: knife-work, brushwork, painting away and line techniques.
Composition: a dynamic line composition with alternating active and passive areas.

Work sequence

It is sometimes difficult to depict an atmosphere or feeling with purely abstract shapes. The colour, shape and composition should all be guided solely by your intuition. If you are using a city, the streetplan can serve as the basis for a line composition.

1 Choose a street plan as the starting point for your composition or, even better, create this from your imagination.
2 Choose a colour scheme that fits the mood.
3 Make an underpainting in different colours on the support.
4 Using the knife, superimpose a number of lines on to the underpainting.
5 Repeat with different colours. The lines created with the painting knife are not smooth and even, and will therefore give extra texture to your work.
6 Paint in smooth areas of colour in various places to break up the line interplay.
7 Decide where you want to have the calm, passive areas and paint away the texture and underpainting by covering with another layer of paint (see the tip below).

Study tip

Try painting almost all of the passive areas in white to reinforce the active area. Both the lines crossing the coloured area and the uniform white colour will give the impression that the composition continues beyond the canvas, and this gives a sense of space.

Impression of an atmosphere.

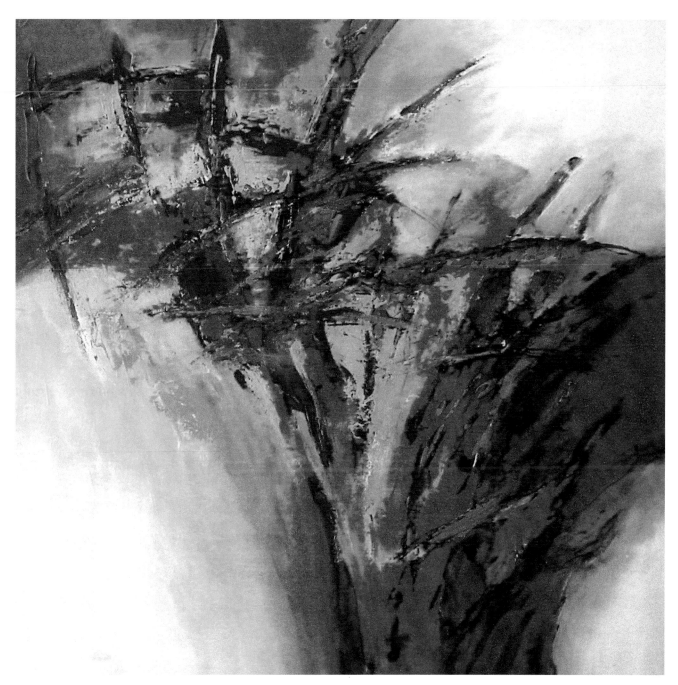

Acrylic on canvas, 80 × 80cm (31½ × 31½in), by R. van Vliet.

Study 6 Textile collage

Study task: create a collage using a variety of textile materials.
Materials: canvas, board or paper, acrylic paint, brush, gesso, glue or acrylic medium and collage material consisting of different types of textiles.
Picture elements: form, colour, texture, harmony, unity, rhythm and pattern.
Techniques: collage, incorporation and glazing techniques.
Composition: build a balanced composition with a horizontal and/or vertical emphasis.

Work sequence

1 Cut the textiles into various shapes.
2 Create a balanced composition with the textiles. Keep in mind that the textures of the different fabrics should be repeated, and distribute them appropriately across the canvas.
3 Fix the components to the background using gesso, glue or acrylic medium.
4 Glaze the first colour layer over both the textiles and support using transparent, liquid paint.
5 Paint the work with your chosen colours so that the materials are incorporated into the whole work and you create unity and cohesion.

Study tip 1

Build up a wide collection of collage materials so that you will always have them to hand when you need them. Think about different types of card and paper, with or without textured surfaces, textiles, wire mesh, metal, wood and rocky materials, packaging, found objects, etc.

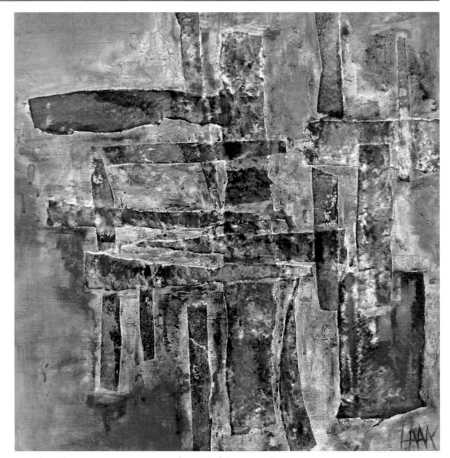

Mixed media on canvas, 40 × 40cm (16 × 16in), by H. Haak.

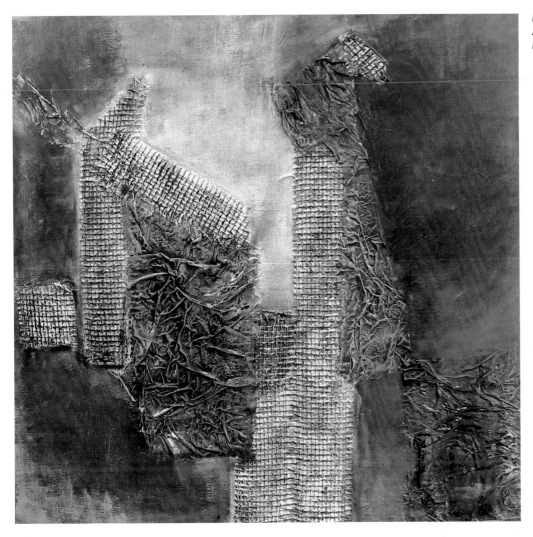

Mixed media on canvas, 40 × 40cm (16 × 16in), by M. Kruithof.

Study tip 2

Limit your choice of materials in a painting to one or two different textures. Avoid creating disorder by using too many textures. Alternate the textured materials with smooth ones. Ensure that the texture of the material used works as a focus and alternates with the tranquillity of the negative surrounding space.

Study 7 *Alla prima*

Study task: create a dynamic composition using a thick, impasto paint.
Materials: canvas, board or paper, acrylic paint, palette knife and powdered stone or sand as a filling material.
Picture elements: form, colour, texture, tone, rhythm, pattern, dynamics, unity and harmony.
Techniques: knife-work, spatula, mixed-media and *alla prima* techniques.
Composition: fill the whole support with a composition in which rhythm, colour, form and texture are equally prominent across the whole image.

Work sequence

1 Prepare the paint by thickening it with the filler material.
2 If you want, mark a number of lines as a starting point using the knife and paint, which can then guide the painting process.
3 Now introduce the *alla prima* technique with the knife by applying short strokes of thick paint and allowing the colours to mix spontaneously. Think about repetitions of colour, shape, texture and rhythm. Show the directions and repeated movements you have used to give an expressive and dynamic end result.

Study tip 1
Thicken the paint so that it is sufficiently sticky and can still be spread. Materials such as sand cause the paint to lose its gloss. If you want to keep the gloss, thicken the paint with heavy gel.

Mixed media on paper, 50 × 70cm (19¾ × 27½in), by J. Stortelder.

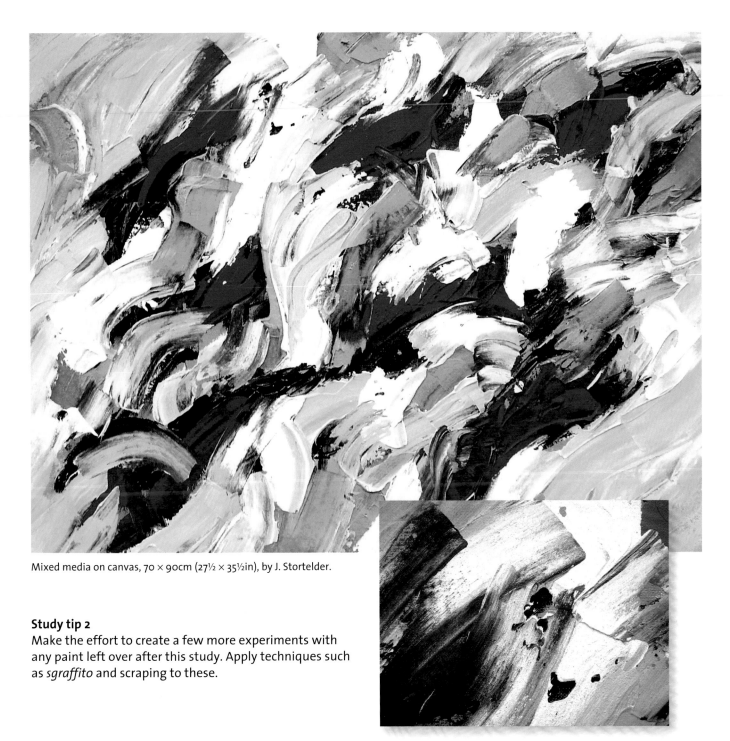

Mixed media on canvas, 70 × 90cm (27½ × 35½in), by J. Stortelder.

Study tip 2
Make the effort to create a few more experiments with any paint left over after this study. Apply techniques such as *sgraffito* and scraping to these.

Study 8 Criss-crossing branches

Study task: using a photograph of a bare tree as inspiration, create a study that depicts the atmosphere of criss-crossing branches. Use the theme purely as an abstraction for the plane division.
Materials: canvas, board or paper, charcoal, acrylic paint, brush and palette knife.
Picture elements: line, tone, form, contrast, rhythm, format, dynamics, unity and harmony.
Techniques: brush, knife and drip-painting techniques.
Composition: use a photograph for inspiration and create a composition with a central focal point. Then find a relationship with the edges of the support using lines that enter and leave the area.

Work sequence

1 First create a sketch on the support with charcoal.
2 Now make the drawing clearer by using a palette knife and black paint.
3 Apply thick, black strokes with the knife in various places and add thinner lines to other areas.
4 Continue with white paint and allow grey hues to appear by overlapping with the black paint in several areas. This will create a visual bridge between the high contrast of the black paint and the white support.
5 Add water to the paint using the brush and apply the drip-painting technique. Carefully use the drops where they can reinforce the active image to give your work a particular rhythm.
6 Finally, paint some areas of the negative surrounding space in solid white.

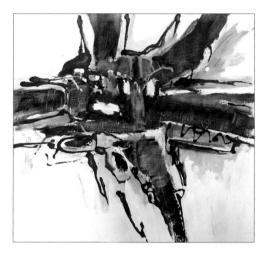

Variation study by R. van Vliet.

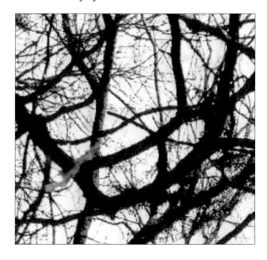

Study tip

Using a photograph is an easy way to start a composition. It does not require much effort to create a whole series of studies. Consider it as a challenge to do this with different colours, techniques and plane divisions. It is an exceptionally inspiring task, so give it a try.

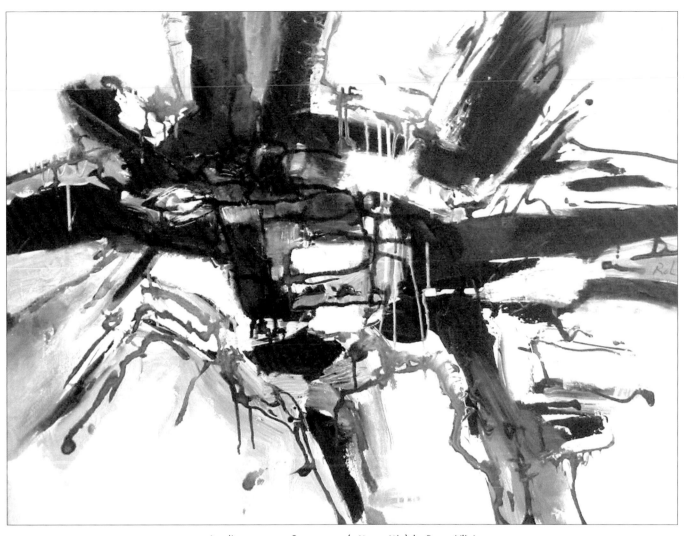

Acrylic on canvas, 80 × 100cm (31½ × 39½in), by R. van Vliet.

Study 9 Composition technique

Study task: design a composition using torn-out, free shapes as your starting technique.
Materials: canvas, board or paper, pencil, acrylic paint, brush and newspapers or coloured paper.
Picture elements: line, form, colour, tone, contrast, unity, harmony, equilibrium and balance.
Techniques: brushwork and shading techniques.
Composition: a free composition that draws attention to active and passive areas and has a central, diagonal emphasis.

Work sequence
1 Start with an underpainting.
2 Tear out a number of different shapes from a newspaper. Build up the composition using these shapes, placing the pieces around the canvas so that they form a pleasing arrangement. Keep in mind the open and free areas that will act as passive surrounding space.
3 Draw a line around the shapes and remove them. Your plane division and composition will now be clearly visible.
4 Paint the whole area.
5 Bring in harmony and unity by brushing colours over each other using the shading technique, which will allow you to weaken the contrasts and enhance unity and harmony.
6 Add any line features to enhance the image.

A

Study tip 1
You can use coloured paper with this composition technique, which will produce an image with colour divisions and tonal differences (A).

Study tip 2
Alternatively, you can stick the pieces of paper to the background and then further incorporate the material into the work (B).

B

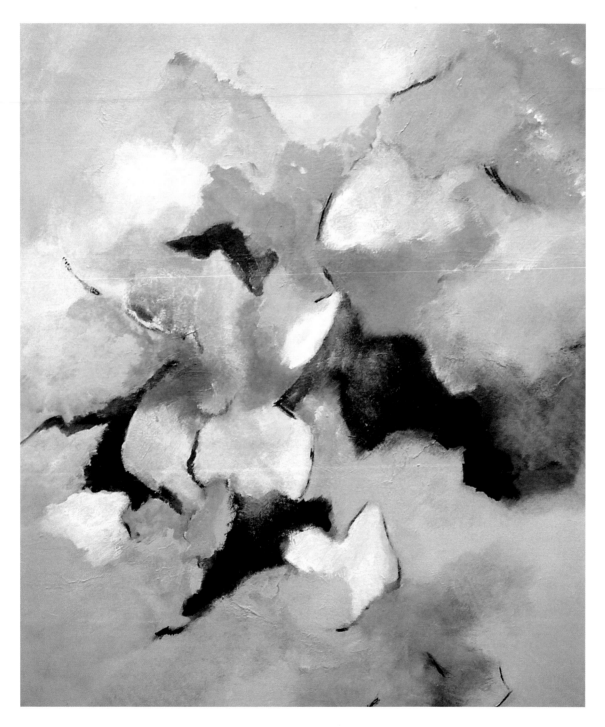

Acrylic on canvas,
50 × 60cm
(19¾ × 23½in), by
K. van Treuren.

Study 10 Playing with lines

Study task: play freely with lines and colours.
Materials: canvas, board or paper, acrylic paint and brush.
Picture elements: line, form, colour, tone, contrast, harmony, rhythm, unity and equilibrium.
Techniques: brushwork and line techniques.
Composition: fill the whole support exclusively with lines.

Work sequence

1 Start with an underpainting.
2 Without doing any drawing beforehand, create random lines on the canvas using a brush. To achieve unity and harmony, it is useful to use round, curved, jagged or straight lines from the beginning.
3 Repeat this process using other colours. By doing so, you will fill the whole area with lines.

Study tip

Repeat the study using other colours and other types of line. Start with another underpainting and use a flat brush in addition to a round brush.

Acrylic on paper,
50 × 60cm (19¾ × 23½in),
by C. Ruyters.

Acrylic on paper, 50 × 60cm
(19¾ × 23½in), by M. van 't
Klaphek.

The challenge

Creating a painting made up solely of line elements is a real challenge. It may seem an easy task, but there are often initial problems because, at the beginning, people do not know how they should fill the area. Bear in mind that variation is particularly important here so use short lines together with long lines, thick and thin lines, and superimpose them at various intervals. The density of the line interplay is a question of perseverance and of thinking up new solutions for the areas that are still 'empty'.

Acrylic on canvas, 40 × 40cm (16 × 16in), by E. Kooloos.

Acrylic on canvas, 60 × 80cm (23½ × 31½in), by A. Stuivenberg.

69

Study 11 Organic forms

Study task: create a work in which the visual language is composed of natural, organic shapes such as leaves.
Materials: canvas, board or paper, acrylic paint, brush, newspapers, a stick to draw with, gesso and texture paste.
Picture elements: line, colour, form, texture, format, rhythm, repetition, pattern, harmony and alignment.
Techniques: texturing, collage, scratching-out and glazing techniques.
Composition: design a composition that fills the whole support and is divided into rectangular shapes (grid composition). Place one or more leaf shapes inside the various rectangles. Think about varying orientation while maintaining equilibrium and balance.

Work sequence
1 Cut out a number of leaf shapes from a newspaper. Create varied shapes and formats.
2 Using a brush and paint, sketch out the rectangular divisions on the support.
3 Stick the cut-out leaf shapes on to the support using gesso or white paint.
4 Cover the remaining areas with a layer of white paint with texture paste and, using a stick, draw leaf shapes into the wet paste.

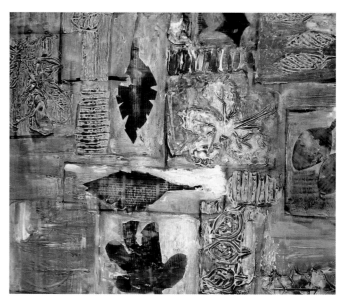

Acrylic on canvas, 50 × 60cm (19¾ × 23½in), by H. Kool.

Stage 6.

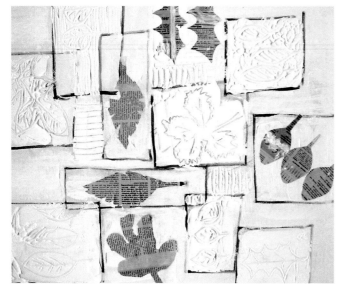

5 Alternate the shapes with a scored, decorative line interplay.
6 Allow the painting to dry thoroughly.
7 Paint the whole support in one colour with diluted paint (glazing technique).
8 Once dried, follow with a second (and possibly third) layer of glaze in another colour.
9 Add opaque, solid paint where necessary.

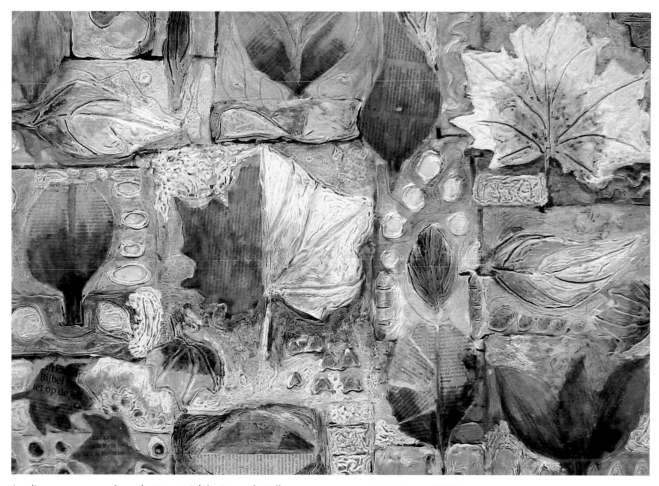

Acrylic on paper, 50 × 60cm (19¾ × 23½in), by R. van de Valk.

Study tip 1
The printed letters from the newspaper act as a special texture. To keep this texture, it is best to cover them with a transparent glaze of paint.

Study tip 2
Turn the canvas horizontally when glazing so that the paint can run into the deeper scored-out areas.

Textural effect.

Study 12 Working from a group photograph

Study task: create a work that is inspired by a group photograph. This can be a random photograph from a newspaper, a family portrait or a photograph of a club or sports team.
Materials: canvas, board or paper, acrylic paint, palette knife and brush.
Picture elements: line, form, colour, tone, texture, rhythm, harmony and unity.
Techniques: expressive painting, *alla prima* and scumbling techniques.
Composition: follow the composition in the photograph or adapt it to your own ideas.

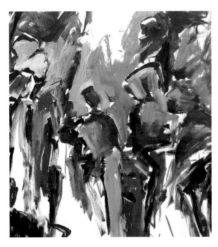

Above, sketch phase.
Right, further colour division.

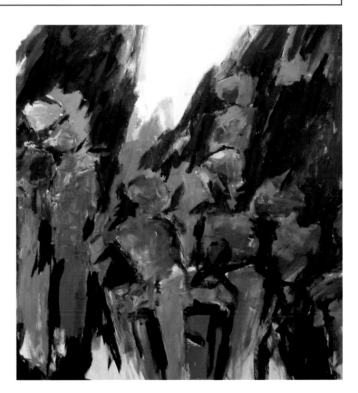

Work sequence
1 Create a number of test sketches based on a group photograph.
2 Select one of these and sketch it roughly on to the support using a brush and paint.
3 Apply colour to the whole area using the *alla prima* technique, so that the right colours will be painted in the right places.
4 Fill the remaining area(s) with colour.
5 Work on texture features, mixing on the support, if needed.

6 To make the whole area appear softer, use the scumbling technique. In other words, knock back colours by brushing over a thin layer of dried paint in a neutral colour.

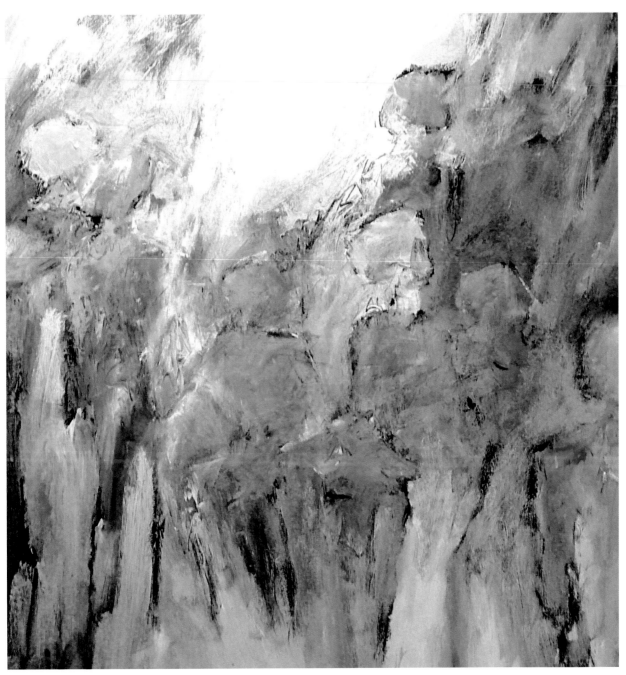

Acrylic on canvas, 100 × 100cm (39½ × 39½in), by R. van Vliet.

Study 13 Stamped patterns

Study task: experiment with patterns and rhythms by making prints from materials you have designed yourself.
Materials: canvas, board or paper, acrylic paint, brush and stamping materials (see tip).
Picture elements: line, form, colour, texture, format, tone, rhythm, unity, harmony and dynamics.
Techniques: brushwork, glazing, paint-flow and stamping techniques.
Composition: create a dynamic composition. Use the diagonal axis and stamp rhythmical patterns over the area.

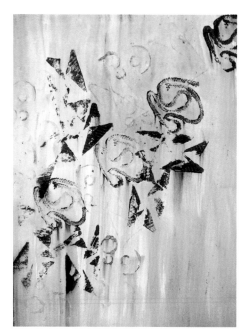

Acrylic on paper, 40 × 50cm (16 × 19¾in),
by R. Arends.

Work sequence
1 Start by applying a multi-coloured underpainting with overlapping colours. Work with liquid paint or brush pure paint over and into each colour.
2 Using different stamps, create patterns over the image area.
3 Repeat using other colours.
4 If you did not start with an underpainting, glaze the whole area.
5 Alternatively, cover alternating areas with opaque paint.

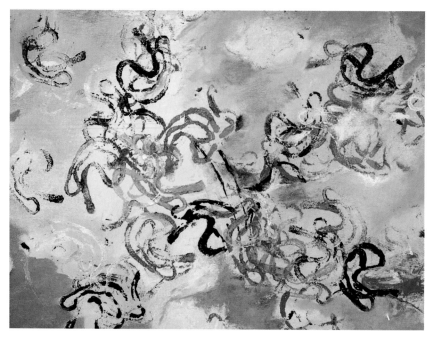

Acrylic on canvas, 50 × 60cm (19¾ × 23½in), by A. Verhagen.

Creating your own style
Using this method, although we do not actually paint any shapes, we did design the shapes at the beginning. This way, the visual language takes on our own creative handwriting.

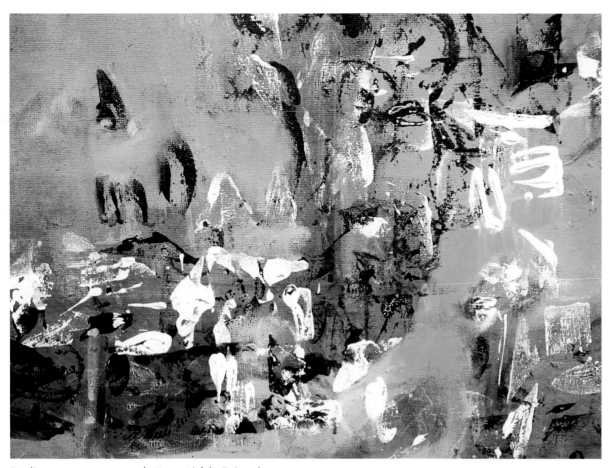

Acrylic on canvas, 50 × 70cm (19¾ × 27½in), by R. Arends.

Study tip

The aim of this study is to investigate the effects of stamps. It is, therefore, essential that you first create a number of stamps. This is the most creative part. Each stamp is, in fact, a shape composition that fills the whole area. In order to introduce variety to your stamps, you need to pay attention to changing the shape and effect. For instance, you can have thin, rhythmical lines or larger, rounded areas. We can use thin blocks of wood or cut-out card for this. We can create irregular patterns by cutting pieces of thick card and fixing them to a small block of wood. Do not forget that you can also use a linoleum off-cut as a stamp. The more variety you create, the more interesting and personal your stamps will become. Then you can use them to add texture and surprising features to your work.

Study 14 Natural texturing materials

Study task: Get to work with materials such as sawdust, ground coffee and straw and incorporate these into a painting.
Materials: canvas, board or paper, acrylic paint, palette knife, sawdust, coffee grounds, straw, brush and gesso or heavy gel.
Picture elements: form, colour, tone, texture, contrast, format, unity and harmony.
Techniques: knife-work, texturing, brushwork and collage techniques.
Composition: create a composition that fills the whole support with mainly rectangular shapes. Think about a balanced division and shapes with varied formats.

Work sequence

1 Apply a layer of gesso or paint to the support and press the straw into this layer while wet.
2 Cover other areas with paint and sprinkle sawdust and/or dried coffee grounds over them. Allow everything to dry properly.
3 Set to work with colour and paint the whole area. Think about light/dark contrast.
4 Alternatively, cover some areas with smooth, opaque paint as calmer points.
5 Outline certain areas in order to enhance the shape.

Study tip 1

Ensure that materials such as sawdust, straw and, especially, coffee grounds are completely dry – otherwise, your work will go mouldy.

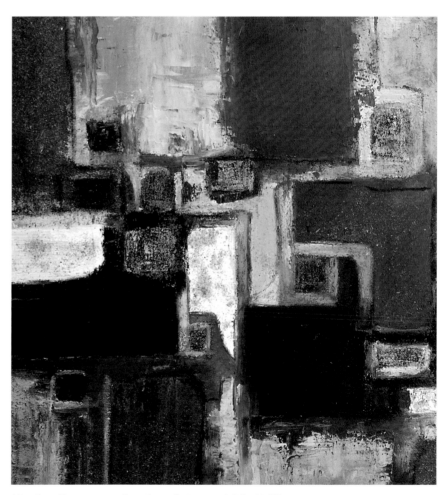

Mixed media on canvas, 60 × 60cm (23½ × 23½in), by M. Pit.

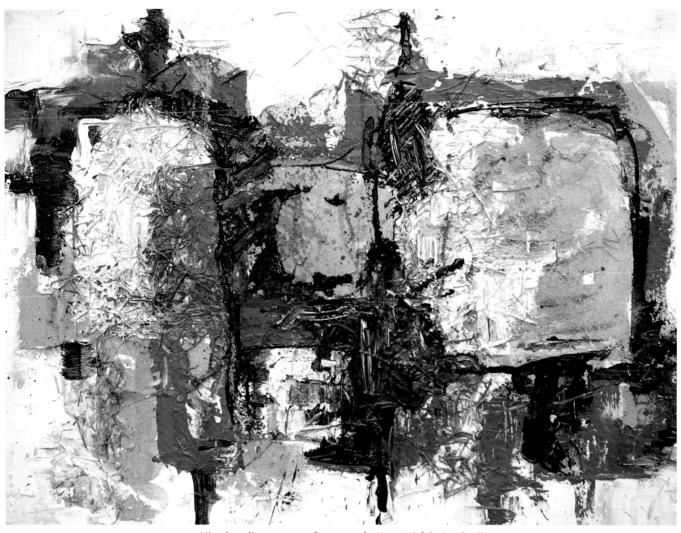

Mixed media on canvas, 60 × 70cm (23½ × 27½in), by J. v. Rooij.

Study tip 2
When we use coarse materials such as straw, or powdery materials such as sawdust and coffee grounds, we must ensure that these delicate materials are properly glued down. It is recommended that you cover any such work with a thick layer of varnish or a layer of transparent gel in order to prevent these added materials from coming loose. This problem does not exist when powder-based materials are mixed into the paint beforehand, although the effect is then a lot less visible.

Study 15 Starting technique

Study task: create a composition that begins with an experimental background with a visual texture.
Materials: canvas, board or paper, acrylic paint, brush, Indian ink and clingfilm.
Picture elements: line, form, colour, texture, tone, harmony and unity.
Techniques: texturing, glazing, drawing and brushwork.
Composition: this composition depends mainly on texture and the composition is secondary to achieving colour and texture effects.

Work sequence

1 We begin by using a special texturing technique. Dilute paint with water and pour on to the support. Apply some clingfilm and press this on to the support so that it creases. Allow the paint to dry and repeat this step with other colours. In this way you will create a multi-coloured background with different, jagged texture effects. If you want clear colours, then dry the work completely in between each step. You can also allow the liquid colours to flow into each other, which will create mixed colours.
2 Now emphasise certain areas by drawing shapes and features using Indian ink.
3 Work everything into a pleasurable image. You can also paint out areas of the texture using opaque paint.

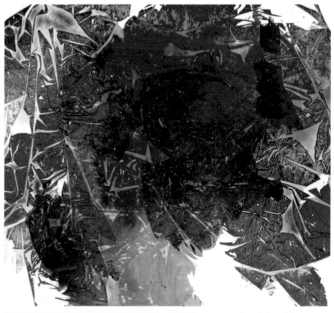

Details of clingfilm texture.

Texture as your inspiration

Texture can be a very inspiring basis for a piece of work. This is certainly true when the effect created by the texture technique, as seen here, is rather uncontrollable and gives a surprising result.

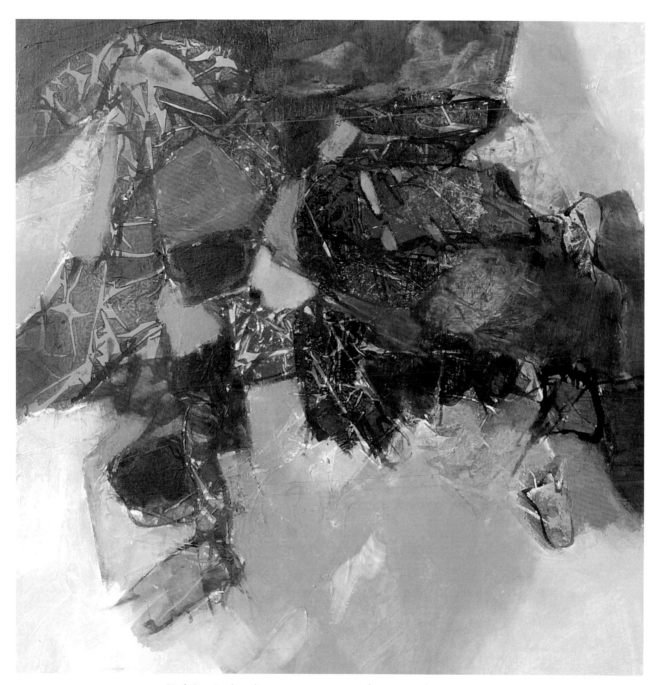

Study in mixed media on canvas, 70 × 70cm (27½ × 27½in), by R. van Vliet.

Study 16 Working with foil

Study task: see what you can do with foil.
Materials: canvas, board or paper, acrylic paint, palette knife, brush, tin foil and gesso or heavy gel.
Picture elements: form, colour, texture, tone, contrast, unity, harmony, equilibrium and balance.
Techniques: collage, glazing, brush and dry-brush techniques.
Composition: divide the support into a number of rectangles or squares.

Work sequence

1 Spread a layer of heavy gel or gesso on to the support.
2 Tear off a few sheets of foil and press these on to the layer while wet. Press down so that the foil becomes creased. Press down firmly and make sure that the foil is properly fixed all over.
3 Allow everything to dry.
4 Apply a coloured glaze. The watery paint will run into the deeper areas of the creases.
5 Repeat using other colours and allow everything to dry.
6 Continue with opaque paint and a dry brush. Work with contrasting colours and cover some underlying parts of the image.
7 Finally, gently wipe a dry brush and paint (dry-brush technique) across the top of the creased foil, causing extra line features to become visible.

Details.

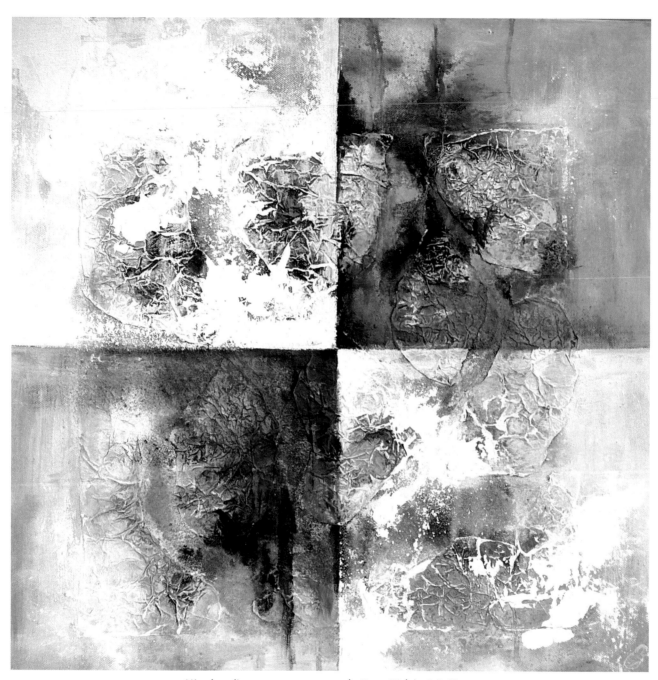

Mixed media on canvas, 50 × 50cm (19¾ × 19¾in), by C. Ruijters.

Study 17 Splash techniques

Study task: create a free work and discover how paint splashes can give texture to your visual language.
Materials: canvas, board or paper, acrylic paint, plastic cups, and medium and fine brushes.
Picture elements: colour, line, texture, tone, contrast, dynamics and harmony.
Techniques: brushwork, splashing, drip-painting and dot techniques.
Composition: the splashes will ultimately determine the way in which the image surface is covered.

Work sequence

1 Start by laying a dark underpainting on the support.
2 Apply several spontaneous patches of colour to create a multi-coloured background.
3 Prepare several plastic cups containing liquid paint. Using the brush, start splashing on the paint and continue with other colours. If you want to keep the colours pure, allow each one to dry before using another colour. Line-type features will appear when you make a lashing motion with your brush and the watery paint.

Acrylic on canvas, 40 × 40cm (16 × 16in), by M. Koelemij.

Acrylic on canvas, 40 × 40cm (16 × 16in), by C. Goedvolk.

Study tip

Use a regular brush or a fine brush that can absorb plenty of water. When splashing, you can determine the direction and position of the splashing effect and so ensure an even distribution.

Acrylic on canvas,
50 × 60cm
(19¾ × 23½in),
by E. Nolens.

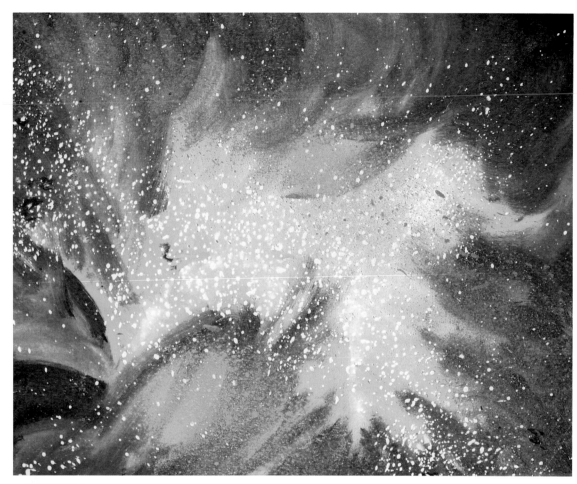

Acrylic on canvas,
30 × 30cm (12 × 12in),
by L. Bouma.

Using the splash technique

The splash technique is especially suited to depicting special effects that are reminiscent of a starry sky or the northern lights. A finer splash technique was used here by tapping the brush containing the paint gently with a finger so that drops but no trails were formed. Extra emphasis can be introduced by adding uniform touches with a fine paintbrush. This technique, in contrast to the usual splash technique, is very easy to control and guide.

Study 18 Inspired by the work of...

> **Study task:** choose a work by a specific painter as your starting point. Study and analyse your source of inspiration. Create several designs of your own and then elaborate them using different techniques.
> **Materials:** canvas or board, paper, pencil, acrylic paint, brush, palette knife, old tea towel, glue or acrylic medium and texture paste.
> **Picture elements:** form, line, colour, texture, format, tone, pattern, orientation, unity, harmony, equilibrium and balance.
> **Techniques:** collage, incorporation, glazing, knife-work, brushwork and line-stamping techniques.
> **Composition:** create a balanced composition in which the image comes into view in a large format (macro format).

Work sequence A – collage technique
1. First draw the design on to paper.
2. Cut out all of the shapes for the artwork and place them on an old tea towel.
3. Now cut the shapes out of the tea towel and stick them firmly on to the support (A).
4. Glaze the areas with colour.
5. Apply opaque paint as desired.
6. Incorporate the thick collage material, if you wish, by introducing printed or painted outlines.

Making the most of the lesson
The 'inspired by...' composition can focus on a particular artist, style, technique or subject. In this case, the style and theme of Dutch painter Klaas Gubbels was chosen. It was especially inspiring to abstract and to find our own variations in transformation, composition and techniques. These are ultimately the learning moments we can experience with the theme 'inspired by...'. Whichever way you do it, always try to get as much as possible out of studies like this.

A

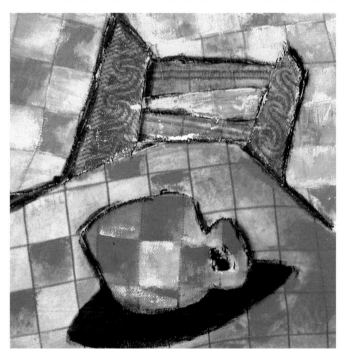

Acrylic on canvas, 30 × 30cm (12 × 12in), by H. Haak. Collage technique.

Study tip
You can, of course, use other types of textiles or paper as collage material. The tea towel was found to be suitable here for stimulating ideas. Furthermore, the striped pattern on the tea towel inspired me to try to achieve equilibrium and orientation.

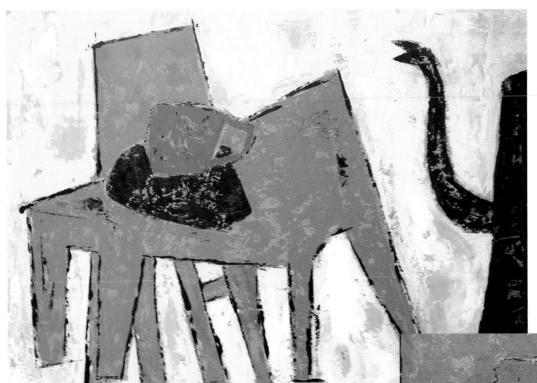

Acrylic on canvas, 60 × 80cm (23½ × 31½in), by H. Haak. Knife technique.

Detail.

Work sequence B – knife technique

1. Draw the subject on paper. Shapes can also run off the image to give the greatest possible feeling of space.
2. Start with an underpainting.
3. Sketch the subject on to the support.
4. Mix the paint in advance with texture paste or another paint-thickening substance and apply the desired colours using the knife. Leave areas of the underpainting untouched to obtain an irregularly coloured and textured surface.
5. You can also work on selected areas with a third layer of paint to bring in colour repetition and harmony.
6. Emphasise the shapes, if desired, by outlining them with a stamped line.

Study 19 Relief technique

Study task: add medium that will enable you to experiment with the relief technique. Use this to emphasise the focal point with colour but choose an almost colour-free negative surrounding area.
Materials: canvas, board or paper (for a very heavy relief effect, use a hard base to prevent the surface from cracking), acrylic paint and stone powder, heavy gel or texture paste and a sturdy palette knife or, even better, a spatula.
Picture elements: form, colour, tone, contrast, texture, harmony and unity.
Techniques: knife-work and *alla prima* techniques.
Composition: choose a composition with alot of empty surrounding space (for example a cruciform composition or a composition with horizontal accents).

Work sequence

1 Determine in advance which type of composition you wish to use. The model will determine where to position the focal point and where the passive surrounding space is located.
2 Prepare the various colours by thickening them beforehand on the palette with the filler until the mix reaches relief thickness.
3 Using a sturdy knife or spatula, first introduce the colours on to the focal point. Do not create a sketch or plane division in advance.
4 Apply white paint to the surrounding area.
5 Brush some of the colour over the white to create unity and cohesion and to weaken the contrast a little. As a result there will be a connection between the active, coloured area and the white, passive surrounding area.
6 Work on unity by bringing white areas into the coloured area and by introducing colour to the white areas.
7 You can develop the texture, if you wish, by scratching or brushing with the knife.

Acrylic on canvas, 40 × 40cm (16 × 16in), by K. Melger.

Study tip
Always look for the connection
between passive and active, but
also between colour and absence
of colour. By using the same
texture throughout, you will be
able to enhance unity
and cohesion.

Acrylic on canvas, 50 × 70cm
(19¾ × 27½in), by L. Sueters.

Detail. J. Stortelder.

Study 20 Visualising memories

Study task: use a memory of a particular meeting which left an impression on you as the starting point for an experimental work.
Materials: canvas, board or paper, acrylic paint, Indian ink, medium and fine brushes, palette knife and tissue paper.
Picture elements: colour, form, texture, tone, contrast, unity and harmony.
Techniques: collage, knife-work, brush, dry-brush and glazing techniques.
Composition: design a composition around your central theme and use overlapping to show depth and cohesion.

Work sequence

1 Practise the composition in advance by making several sketches.
2 Cover the support with creased tissue paper and leave it to dry. The lines of the creases will create a crackle-type effect.
3 Using a fine brush and ink, sketch out the main shapes.
4 Apply colour to the whole area. Use the dry-brush technique by lightly brushing over the texture lines with paint and a dry brush.
5 Repeat this process various times using different colours.
6 Apply a glaze to the remaining shapes.
7 Finally, paint larger areas with opaque paint to create calm surrounding areas.
8 To reveal the shapes more clearly, they can be painted in profile by painting another colour against them.

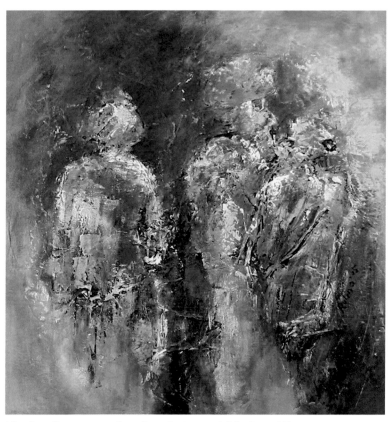

Mixed media on canvas, 60 × 60cm (23½ × 23½in), by R. van Vliet.

Study tip
When you use outlines of human figures as the main shapes in your work, it is extremely important to observe people regularly, and to make studies of proportions and of groups of people based on your observations.

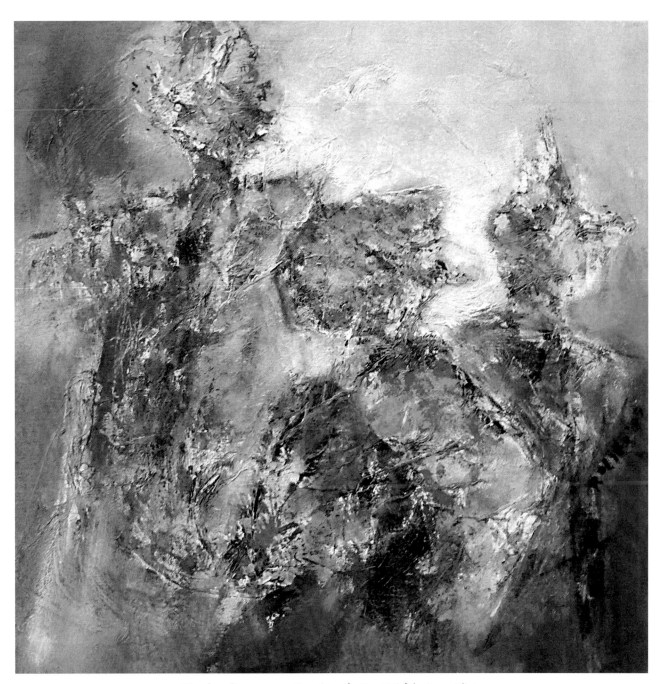

Mixed media on canvas, 60 × 60cm (23½ × 23½in), by R. van Vliet.

Study 21 Building up texture

Study task: create a work in which texture adds a striking effect.
Materials: canvas, board or paper, acrylic paint, brush, palette knife and gesso or texture paste.
Picture elements: form, colour, texture, tone, contrast, dynamics and unity.
Techniques: texturing and dry-brush techniques.
Composition: create a composition with horizontal emphasis and space for passive, calm areas.

Work sequence

1 Apply an underlayer of gesso or texture paste to the support. Make the layer as rough as possible by using a palette knife. Allow it to dry.
2 Apply a second rough layer using a brush and black paint.
3 Allow to dry and repeat with a third layer in a lighter colour. By now an underpainting will have appeared in which all of the brush and knife strokes from the previous layers will form the texture.
4 Doodle a shape composition on this underlayer.
5 Now create the upper painting using contrasting colours. First use the dry-brush technique by wiping a dry brush and a little paint lightly across the texture. By using this technique, the background hues will remain visible.
6 Vary the texture by masking out areas so that the visible texture disappears. These areas project tranquillity in relation to the areas with visible texture.

Detail.

Example of dry-brush technique.

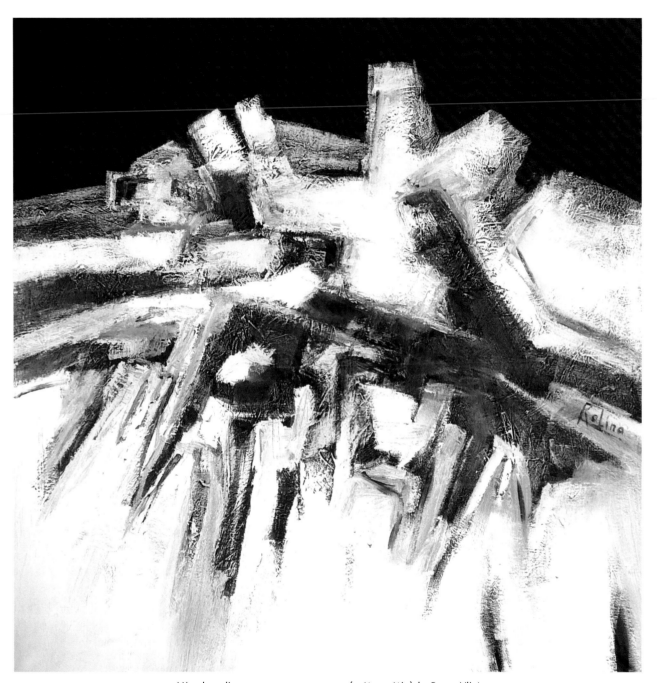

Mixed media on canvas, 100 × 100cm (39½ × 39½in), by R. van Vliet.

Study 22 Lines with a knife

Study task: experiment with line effects using a palette knife.
Materials: canvas, board or paper, acrylic paint, brush and palette knife.
Visual elements: line, colour, texture, tone, dynamics, rhythm, unity, harmony and balance.
Techniques: line, scraping and brushing techniques with a palette knife and painting-away technique.
Composition: create a dynamic, open composition that fills the whole area and extends beyond its edges.

Work sequence

1 If desired, start with an underpainting. Choose a darker colour for this if you want to continue working with light colours or vice versa.

2 Using the knife and paint, apply large, dynamic strokes across the support. Draw lines lengthwise using the knife. If desired, make score marks on the strokes.

3 In this way, work each new colour on top of the other(s).

4 Carry on working until there is rhythmical line interplay across the whole of the support.

5 If desired, paint away areas with opaque paint in order to create calm in the image and establish a contrast between the texture and surrounding shape.

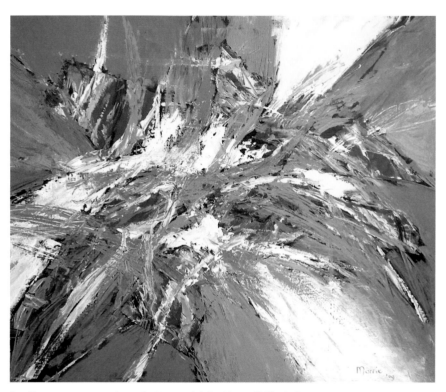

Acrylic on canvas, 50 × 60cm (19¾ × 23½in), by M. van 't Klaphek.

Study tip

If you dare, try creating a similar work on a very large format canvas without doing any sketching beforehand. Work no smaller than 100 × 100cm (39½ × 39½in). This technique shows a high degree of expression and you will literally bring space to your work.

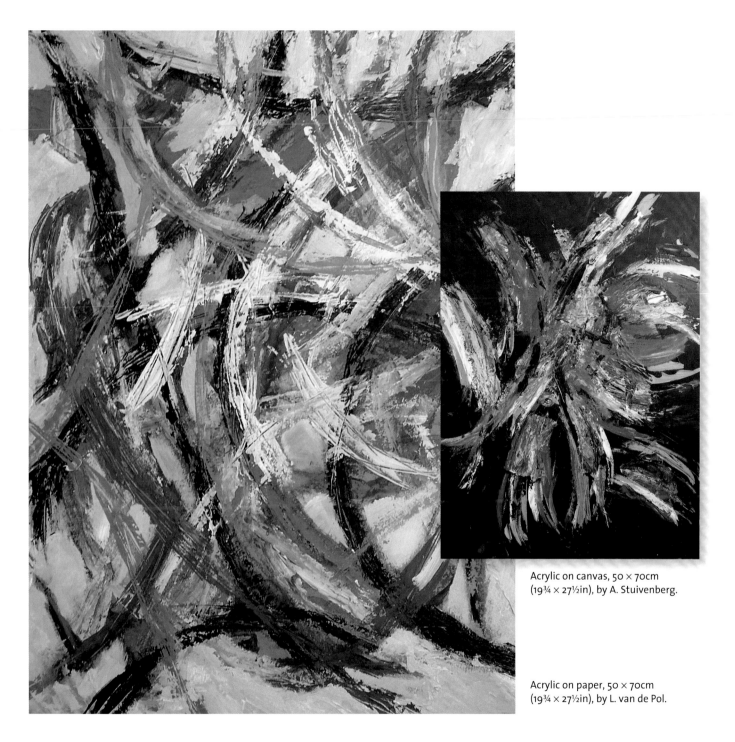

Acrylic on canvas, 50 × 70cm
(19¾ × 27½in), by A. Stuivenberg.

Acrylic on paper, 50 × 70cm
(19¾ × 27½in), by L. van de Pol.

Study 23 The chair of...

Study task: create a design inspired by the theme 'the chair of...'. Abstract the theme as much as possible and create something personal from this.
Materials: canvas, board or paper, pencil, acrylic paint, brush, palette knife and texture materials, if required.
Picture elements: colour, line, form, texture, tone, contrast, harmony, unity and equilibrium.
Techniques: brushwork, knife-work, line-stamping and scratching-out techniques.
Composition: use a composition that extends beyond the edges to give a sense of space.

Work sequence

1 Create a sketch for your design. You are going to start with the shape of a chair that means something to you. Make that into something personal.
2 Using a pencil, sketch the composition on to the support.
3 Choose a technique for producing the work.

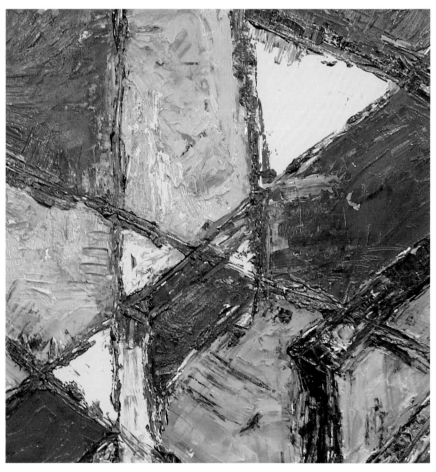

Study tip

For designs based on reality, we can use the rules of abstraction. This will result in it becoming steadily less recognisable. When using the same colours and extra lines for both the shape and the background, this will further enhance the abstraction.

Acrylic on canvas, 40 × 40cm (16 × 16in), by H. Kool.
Created using a palette knife, filler, texture and scratching technique.

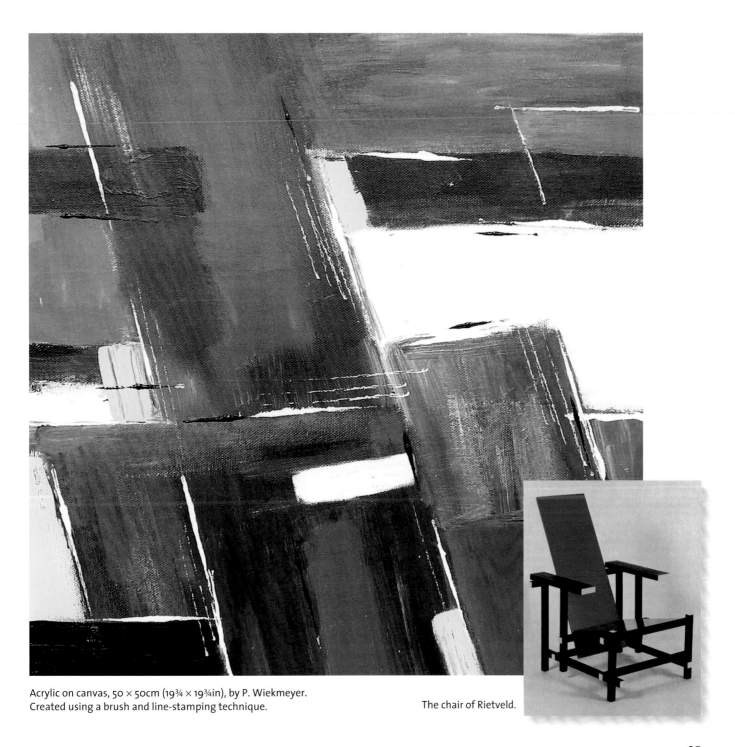

Acrylic on canvas, 50 × 50cm (19¾ × 19¾in), by P. Wiekmeyer.
Created using a brush and line-stamping technique.

The chair of Rietveld.

Study 24 Perception of music

Study task: allow yourself to be inspired by the melody, sound and atmosphere of a particular piece of music or the work of a certain composer.
Materials: canvas, board or paper, acrylic paint, brush, palette knife and texture materials.
Picture elements: colour, texture, line, dynamics, rhythm, repetition, unity and harmony.
Techniques: spontaneously use all techniques and tools that express the feelings you want to bring to your canvas. Using a knife and/or brush, scratch, rub, scrape, drip, stamp, wipe, shade, drop and splash.
Composition: allow the composition to grow during the painting process. Give full space to any intuitive actions during this process.

Work sequence
There is no strict sequence to be followed. The various techniques and methods will be continually repeated. A totally free and spontaneous painting process guided by a particular perception of music cannot follow a prescribed step-by-step sequence.
Choose your colours using your intuition. Use all techniques and materials that come to mind. Brush, clean, scratch, scrape, etc. Just let it all happen. Follow your feelings and express your musical experience.

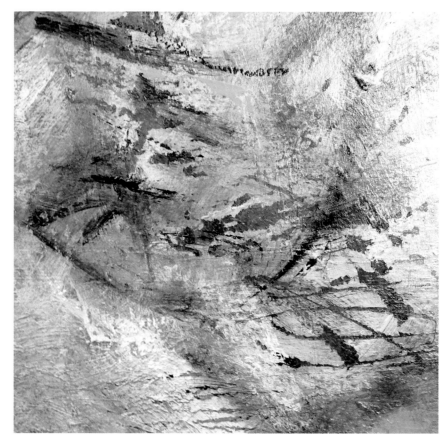

Detail.

Free expression
I hope that you will reach the stage where you are driven and inspired to bring everything into your work that reflects your mood, character and perception. This is highly recommended.

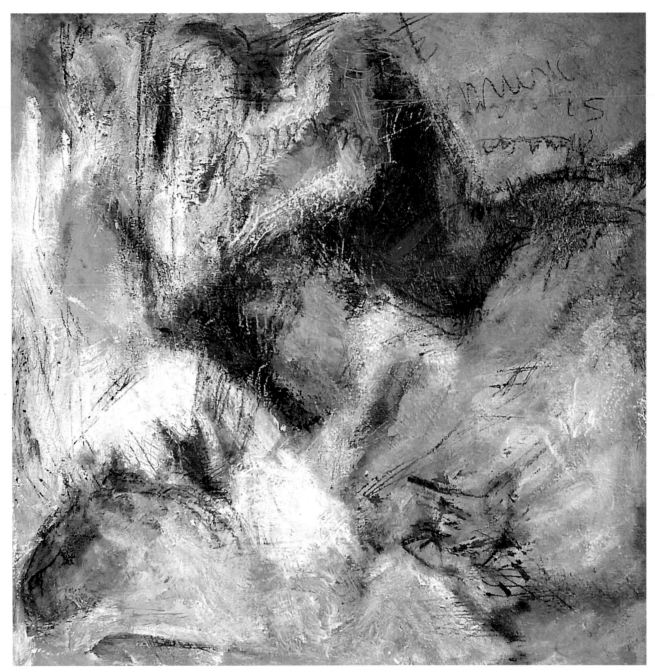

Acrylic on canvas, 80 × 80cm (31½ × 31½in), by B. Wildstrom.

Study 25 Skies

Work sequence

This sequence is for the type of effect shown in the painting opposite.

1 Using your memory and powers of imagination, first sketch a simple plane division.
2 Choose a colour scheme that combines with the atmosphere and mood you want to depict and apply colour spontaneously on to the support. Leave the dynamics created by the brush strokes.
3 In certain areas, thin the paint while still wet by adding water to the paint using an atomiser or a brush. This will create line-style effects (drip-painting technique).

Study in watercolour and Indian ink, 30 × 40cm (12 × 16in), by R. van Vliet.

Study tip 1

Repeat this study with different materials, using a completely watery paint-flow technique as in the image shown on this page.

Study tip 2

When experimenting with the paint-flow technique, you can use diluted acrylic paint, watercolour paint or Ecoline and other types of coloured ink.

Study tip 3
Be careful that the drip-paint technique does not get out of hand. You should only use it where it adds something substantial to the overall effect. With this type of technique you can have too much of a good thing. Therefore, keep a firm control!

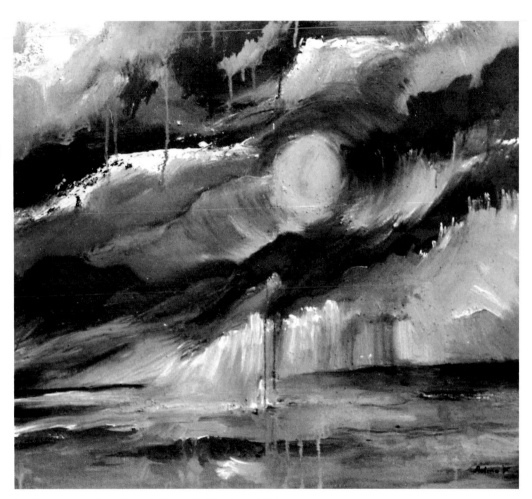

Acrylic on canvas, 60 × 60cm (23½ × 23½in), by R. van Vliet.

Drip-painting technique
The line effects produced by the drip-painting technique add vertical elements to the composition. These balance out the horizontal domination of the composition.

Study 26 Flowers

Study task: abstract the theme 'flowers' into shapes and create your own composition.
Materials: canvas, board or paper, pencil or charcoal, acrylic paint, brush, palette knife and a piece of card.
Visual elements: line, form, colour, format, harmony and unity.
Techniques: line-stamping, knife and brush techniques.
Composition: design a plane division with large shapes extending beyond the image area (macro format).

Work sequence

1 Sketch a number of flowers from memory. Abstract these to their essence and in this way design your composition with several large, overlapping shapes.
2 Make a coloured underpainting. Use a brush to achieve a smooth surface or use a palette knife for a textured surface.
3 Sketch the shapes on the support.
4 Paint the shapes by applying colour using the brush or palette knife.
5 Rhythmically stamp outlines on to the work using a sturdy piece of card. This will emphasise the shapes.

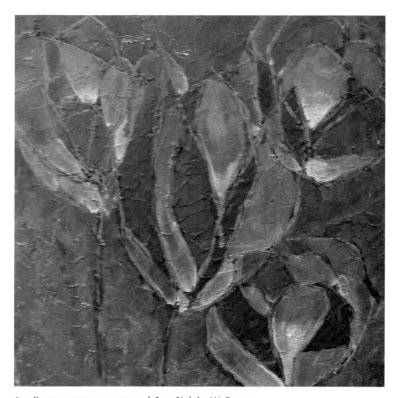

Acrylic on canvas, 40 × 40cm (16 × 16in), by W. Bosma.

Outlines stamped with the edge of a piece of card.

Study tip 1

The even underpainting serves as a background through which the shapes are clearly defined (see illustration). When you apply the same colours and textures to the background as to the flower shapes (see illustration above) they will become more absorbed by the whole image. This will cause the work to appear more abstract because the depth element will be less visible.

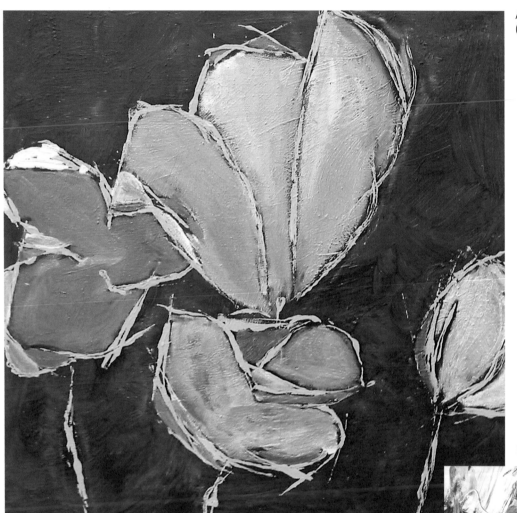

Acrylic on canvas, 40 × 40cm (16 × 16in), by L. Bouma.

Design sketch using a knife.

Study tip 2

When shapes extend and run out of the visual area, it gives the feeling of space as if they continue beyond the canvas. In this way we involve the whole image area in our work.

Study 27 The newspaper as a visual language

Study task: create a composition reminiscent of a weather-beaten, old hoarding on which many posters have been pasted.
Materials: canvas, board or paper, acrylic paint, brush, palette knife and old newspapers or magazines.
Picture elements: colour, form, texture, tone, unity, dynamics and harmony.
Techniques: knife-work, brushwork, collage, incorporation, scraping and tearing techniques.
Composition: fill the whole support, arranging the texture of the collage materials to create focal moments randomly distributed across the visual area.

Work sequence

1 If you wish, you can begin the composition with an underpainting.
2 Tear pieces of collage material from an old newspaper or magazine and fix them with paint on to the background. If possible, partly scrape remnants of paint over the areas that have been stuck down. This will make them immediately part of the whole image.
3 Repeat this process until the whole area has been covered with newspaper cuttings.
4 Further incorporate the material by painting away areas with opaque paint and blurring areas by scraping thin paint over them using a palette knife.
5 Some areas can be painted more evenly to give tranquillity to the image.

Finally, tear off actual pieces of the composition to enhance the desired effect.

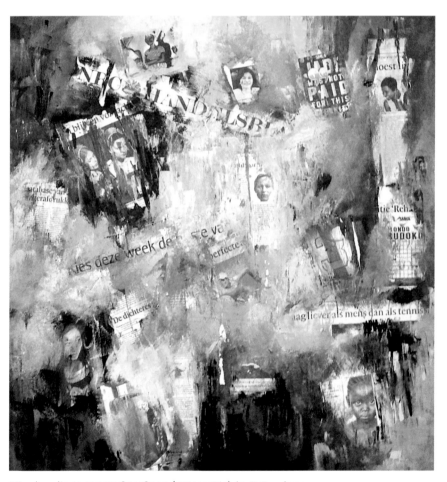

Mixed media on canvas, 80 × 80cm (31½ × 31½in), by D. Engelsman.

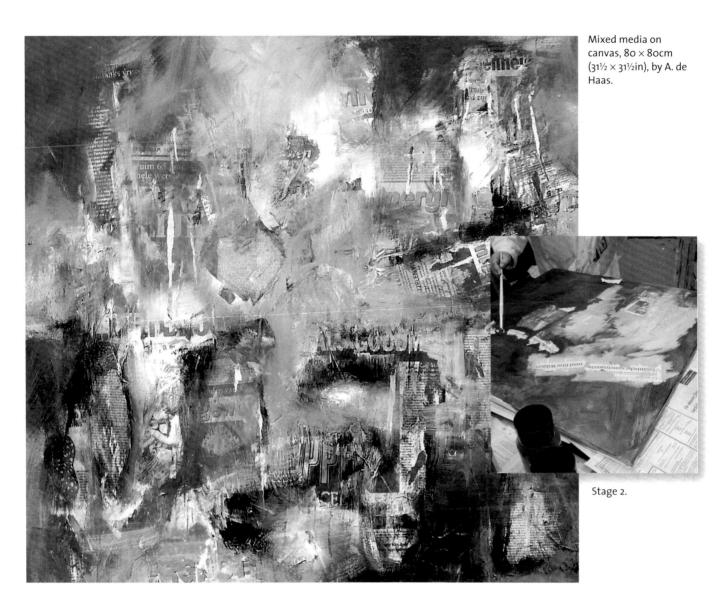

Mixed media on canvas, 80 × 80cm (31½ × 31½in), by A. de Haas.

Stage 2.

Study tip

The collage material can be used in a completely random order. In this case, the images and texts would not really be intended to express any particular thought. If you would like your work to communicate a 'message', then you will naturally choose specific images and texts that can remain slightly more visible in order to support it. Be careful that the text does not have such a strong presence that you are unable to 'see' the rest of the painting.

Study 28 Inspired by photographs

Study task: allow yourself to be inspired by a photograph from your own photo album and use this for a linear work.
Materials: board, acrylic paint, sketching materials, fine brush, soft brush, bottle with a small nozzle and ink.
Picture elements: line, form, dynamics, unity and harmony.
Techniques: line drawing, spray and glazing techniques.
Composition: use a frame composition so that the whole image is surrounded by a frame.

Work sequence

1 Find a number of photographs from your album to be worked on using a line technique.
2 Practise sketching with a pencil and paper to get the most spontaneous possible image.
3 Next practise drawing using a fine brush and ink and repeat this with a bottle with a small nozzle filled with diluted acrylic paint.
4 The drawing should now be brought directly to the support using spray paint or ink and brush. You can also use a combination of these.
5 Add several colour variations using the brush and diluted paint. For a black-and-white photograph, use neutral and weak hues. If you are working with a colour photograph, adjust the colour accordingly.

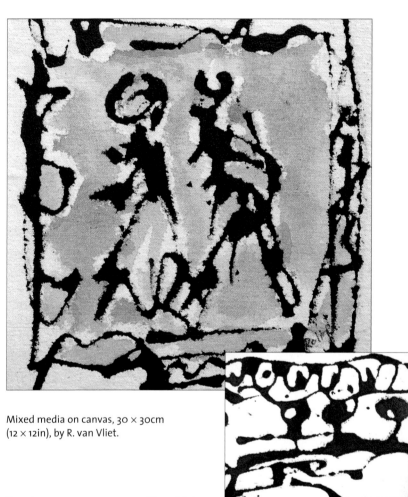

Mixed media on canvas, 30 × 30cm (12 × 12in), by R. van Vliet.

Drawing on canvas, 20 × 30cm (8 × 12in), by R. van Vliet.

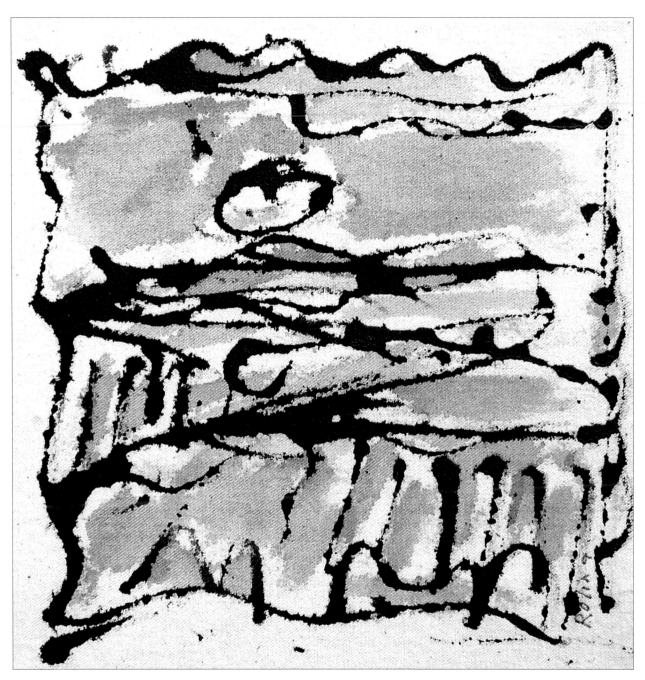

Mixed media on canvas, 30 × 30cm (12 × 12in), by R. van Vliet.

Study 29 Circular composition forms

Study task: create a composition that emphasises a circular composition with a central focal point.
Materials: canvas, board or paper, acrylic paint, brush and charcoal.
Picture elements: colour, form, line, tone, format, contrast, unity and harmony.
Techniques: brushwork and decorative drawing techniques.
Composition: create a shape composition that fills the whole support and has a central focal point with visual lines radiating from the centre.

Work sequence

1 Divide up the canvas area with free shapes, starting in the centre. With the focal point in mind, place smaller shapes in the centre and larger shapes around the edges.
2 Start with an underpainting. Sketch out the boundaries on the canvas with charcoal or a brush and paint.
3 Choose a monotone or analogous colour scheme and work on the whole image with paint and a brush.
4 To create tonal variation and focus, create several darker and lighter emphasised areas.
5 Finally, to give more emphasis, add several decorative, hand-drawn elements.

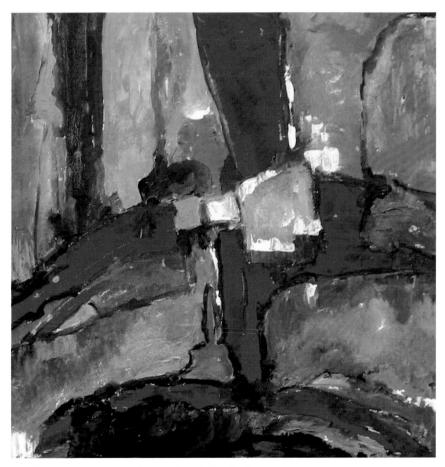

Acrylic on paper, 30 × 30cm (12 × 12in), by C. Goedvolk.

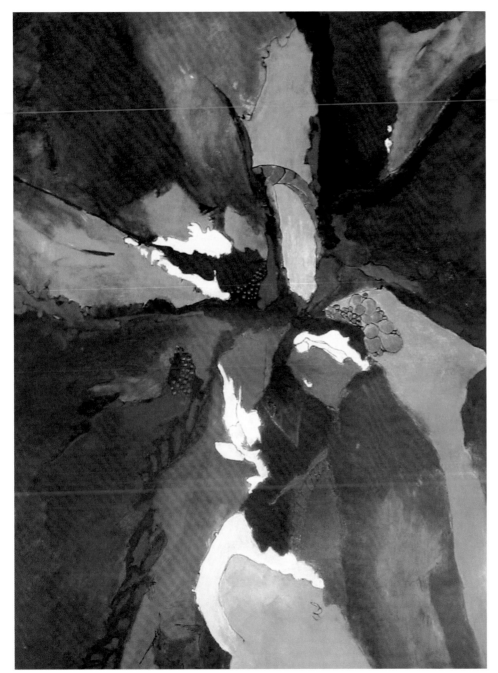

Study tip
The danger with radial compositions is that the eye is drawn too much towards the centre. To avoid this, it is best to use other attention-catching features along the radial lines. There is therefore enough happening in the 'outer area' to keep the mind busy and, as a result, we are able to 'see' the whole painting.

Acrylic on paper, 60 × 80cm (23½ × 31½in), by C. Goedvolk.

Study 30 Rhythm

Study task: create a composition in which repetition, rhythm and pattern fill the whole area.
Materials: canvas, board or paper, acrylic paint and brush.
Picture elements: line, colour, tone, format, contrast, harmony, unity, rhythm, pattern and equilibrium.
Techniques: line and *alla prima* techniques.
Composition: fully elaborate this into a composition that fills the whole support.

Work sequence

1 Begin with an underpainting.
2 Choose your colour scheme and spontaneously apply the *alla prima* (direct) strokes closely together so that a rhythm or pattern is repeated.
3 Fill the whole image area this way and think about colour, line and pattern repetition.

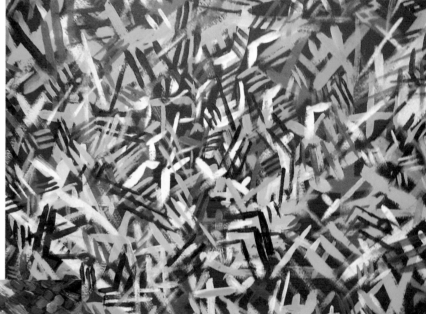

Acrylic on paper, 50 × 60cm (19¾ × 23½in), by J. Stortelder.

Acrylic on paper, 50 × 60cm (19¾ × 23½in), by S. Koopman.

Study tip
Repeat this simple study using other colours, and think about using a neutral or analogous colour scheme. Also try to create variation and rhythmical patterns using figurative shapes.

Further options

Filling a canvas with rhythmical patterns can be completely free, and does not require you to think about any particular composition. We can also fill the canvas with stripy blocks and create a particular composition from this with the help of format and colour variation. This is shown in the work by M. v. Woudenberg (below), in which a cruciform composition has been created.

Acrylic on canvas, 80 × 100cm (31½ × 39½in), by M. v. Woudenberg.

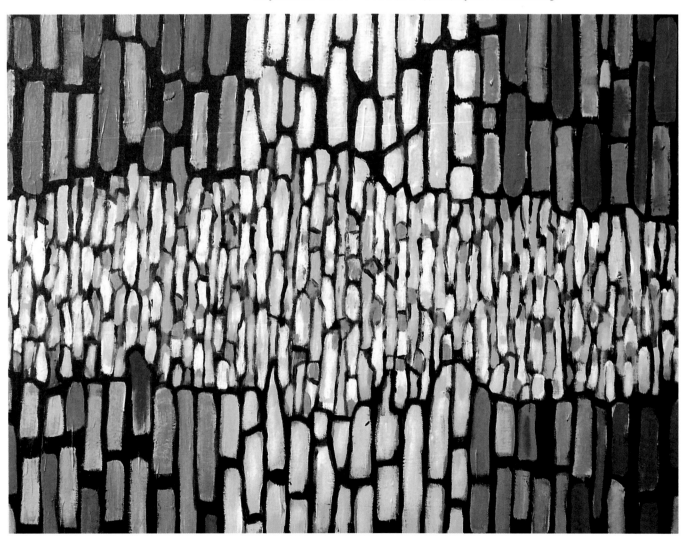

Study 31 Picasso-style design technique

Study task: create a composition based on the theme of 'music' in the style of Picasso. For this design cut out the desired forms, cut them into pieces and place them separately on to the composition.
Materials: canvas or board, drawing media, acrylic paint, brush, collage material and glue.
Picture elements: line, form, colour, texture, format, tone, unity, harmony, repetition and equilibrium.
Techniques: collage, integration and brushwork.
Composition: let the collage material and shapes of the theme determine the focal features.

Work sequence
1 Draw a number of (musical) shapes to use. Cut them out and design a whole composition using other collage material if required.
2 Draw the design on the support and fix the collage material on top of this.
3 Paint the shapes and the surrounding space.
4 Add lines, contrast and texture where necessary.

Study tip
You can apply the Picasso technique to any figurative shape. Because the shapes are cut into pieces and the parts are placed completely freely and in different directions in the composition, the result is an extremely distorted and therefore abstracted effect. It is a wonderful and challenging way to play with reality. Moreover it is a very powerful exercise for training your feel for variation, contrast, cohesion, unity, harmony and equilibrium in compositions.

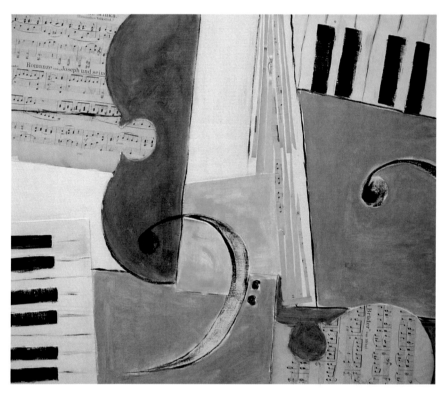

Mixed media on canvas, 50 × 60cm (19¾ × 23½in), by H. Haak.

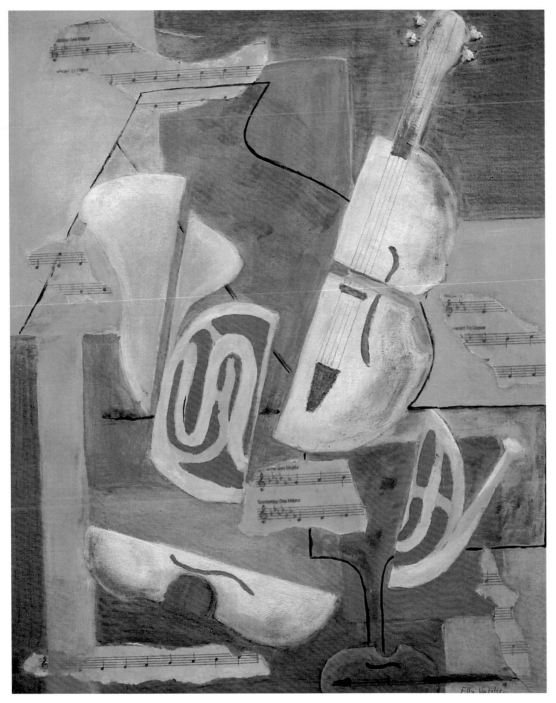

Mixed media on canvas,
50 × 60cm (19¾ × 23½in),
by E. Wateler.

Study 32 High key, low key

Study task: create a free and dynamic study with a dark or light appearance.
Materials: canvas, board or paper, acrylic paint, brush, palette knife and texture paste.
Picture elements: line, form, colour, texture, format, tone, variation, unity, harmony and equilibrium.
Techniques: brushwork, texturing, line and paint-flow techniques.
Composition: create a free composition with a central focal point.

Work sequence

1 Begin by creating an underpainting in either light or dark tones.
2 Loosely sketch shapes that emphasise the diagonal direction to bring action to the work.
3 Work with colour, masking with darker hues or light, transparent, pastel-coloured hues.
4 Bring in contrast by enhancing the light/dark effect.
5 If required, brighten up the whole composition by adding additional texture or line effects.

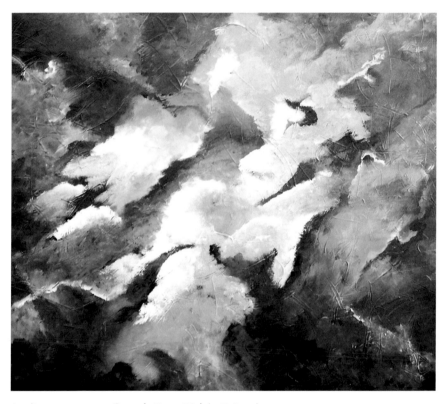

Acrylic on canvas, 70 × 80cm (27½ × 31½in), by D. Engelsman.
Texture technique using paste for the background.

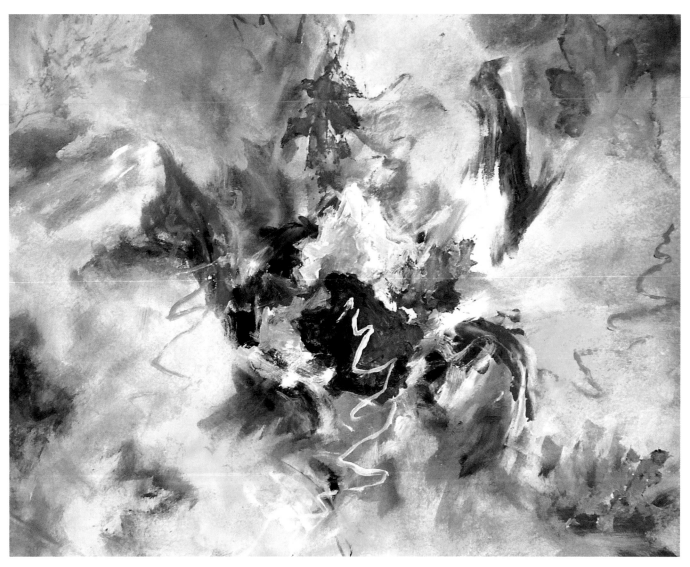

Mixed media on paper, 50 × 70cm (19¾ × 27½in), by H. Feringa.
Transparent paint-flow technique with a watercolour background.

Dark in light, light in dark
Light tones dominate in high-key works while in low-key works, darker tones prevail, but a predominantly light work will contain a lot of dark features and a predominantly dark work will also have light areas of colour. This is in order to enhance dominance by means of variation and contrast.

Study 33 Text as a visual language

Study task: create a study with letters or words as the visual language.
Materials: canvas, board or paper, acrylic paint, paint brush, palette knife, newspaper, collage materials, glue or acrylic medium and scissors.
Picture elements: line, form, colour, texture, tone, rhythm, repetition, pattern, unity and harmony.
Techniques: collage, incorporation, knife and brush techniques.
Composition: create a composition that is divided into variable rectangles. Think about the horizontal and vertical equilibrium.

Work sequence

1 Begin with an underpainting or start directly on the white canvas.
2 Select your collage material and introduce equilibrium to the composition. Fix the material on to the support using glue, paint or acrylic medium.
3 Now paint the whole area using the knife and/or brush so that the words or letters are incorporated into the whole image (incorporation technique). By partially blurring the text you will add tension to the work, so we have to pay extra attention to pick out the punctuation marks.
4 Ensure that the text and letters blend into the rest of the support to create unity and cohesion.
5 Finish the composition by introducing contrast and line emphasis in order to add a little extra intensity to the blurred image.

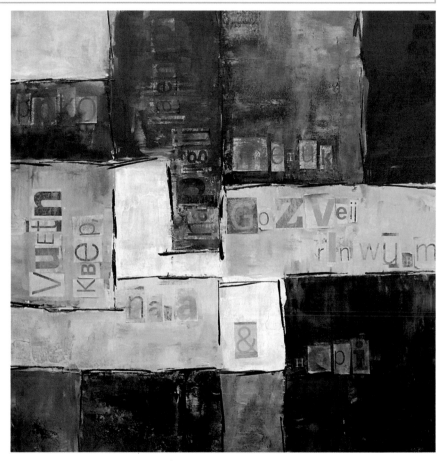

Acrylic on canvas, 40 × 40cm (16 × 16in), by M. Kruithof.

Study tip
You can create the letters and words by cutting them out of a newspaper or magazine. Of course you can also draw out the letters yourself or introduce them on to the canvas using letter stamps or letter templates.

The functions of words and letters

Using text as a visual language gives us the opportunity to give our work a certain idea or 'message'. Furthermore, as an abstract painter we are also familiar with using text that does not convey meaning but is used for the rhythm and pattern that the words and/or individual letters can add to our work as a visual language. If we are dealing with meaning, the emphasis is on the horizontal direction, as shown in the painting by P. Wiekmeyer. If we are dealing with letters as a depiction of rhythm and pattern, then opt for more dynamics and use different orientations as in the piece by M. Kruithof. The words and/or letters function in both cases as focus features.

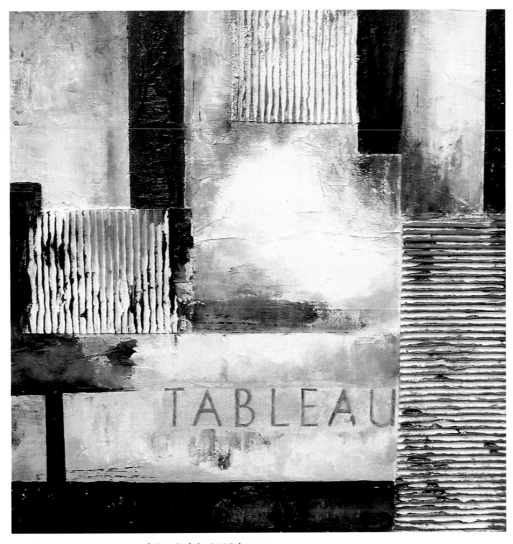

Acrylic on canvas, 40 × 40cm (16 × 16in), by P. Wiekmeyer.

Study 34 Micro and macro formats

Study task: create two studies with flowers or flowery shapes in mind in both micro and macro formats.
Materials: canvas, board or paper, acrylic paint, foil (optional), brush and palette knife.
Picture elements: colour, form, texture, tone, format, dynamics, harmony and space.
Techniques: brushwork, knife-work, texturing and *alla prima* techniques.
Composition: create one composition in micro format and another composition in macro format. In other words, one composition containing very small shapes surrounded by a large, free space and another composition containing several large shapes that fill the canvas and extend beyond the image and therefore search for space.

Work sequence
1 Create a quick, flowery design for both compositions.
2 Begin with an underpainting. If you wish, you can add foil prints (see study 15) to this as a base texture.
3 Apply colour to the whole area using pure paint (i.e. not diluted with water) with a brush or knife.
4 Cover any desired passive areas with an even covering of paint to provide a calm balance to the active areas.

Study tip 1

With a figurative theme, such as flowers, it is better if we can draw from our memories and experiences. The fact is that painting flowers 'from your mind' is always more spontaneous and free than when the flowers are in front of you. When we create sketches from memory, all the details have already faded and we work with a more universal and therefore abstract shape. In this way we can capture the atmosphere and essence of flowers and depict them in a completely personal manner. It is a necessity that we already have sufficient visual memories to express the 'flowers' theme.

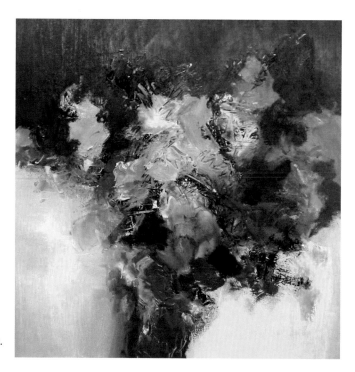

Study in acrylic on canvas, 70 × 70cm (27½ × 27½in), by R. van Vliet.

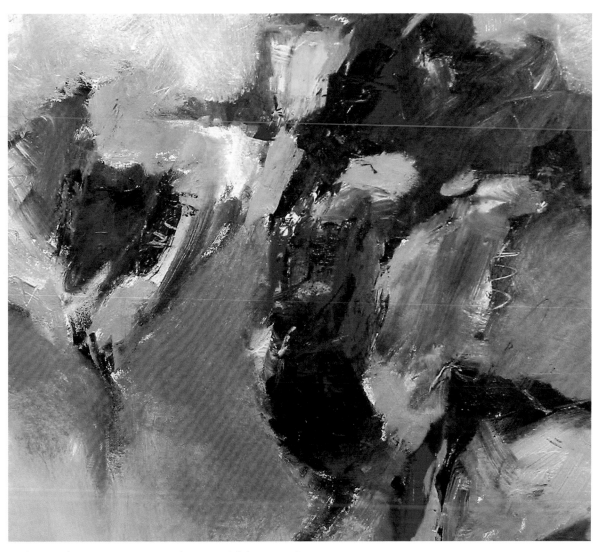

Study in acrylic on canvas, 50 × 50cm (19¾ × 19¾in), by R. van Vliet.

Study tip 2

When you create large shapes, try to use large tools so that you can draw them in one stroke. Choose a broad brush and knives with a wide blade or simply use a piece of card that will allow you to make large sweeps across the support.

Study 35 Abstraction technique

Study task: choose a figurative subject and abstract it with the help of a double composition.
Materials: canvas, board or paper, pencil or charcoal, acrylic paint and brush.
Picture elements: line, form, colour, format, tone, contrast, unity, harmony, equilibrium and balance.
Techniques: composition, brushwork and negative-line techniques.
Composition: use large, abstracted shapes that overlap transparently. Place a second (grid) composition on top of this with horizontal and vertical lines that cut through the image.

Work sequence
1 Begin with an underpainting.
2 As a starting point, choose a straightforward shape, such as a simplified tree shape, and draw out several of these in outline form, placing them on top of and through each other. Create the sketch on the support using pencil or charcoal.
3 Now place the second composition on top of this. Draw a number of straight lines across the image area that pass straight through the tree shapes. Place them both horizontally and vertically or use slanting lines. With this double line composition in place, the image area will be divided into a large number of small blocks.
4 Apply colour to all of the blocks. Think about colour variation, repetition and division. As the colour is applied within the lines, the lines appear to be left out (negative line effect) and give a stained-glass effect.

Acrylic on canvas, 50 × 70cm (19¾ × 27½in), by J. v. Treuren.

Study tip 1
Working with a double composition helps to blur the realism of the theme. Naturally we can work using rigid shapes with a freer style of painting to make the shapes less defined. If, on the other hand, we want to enhance the rigid image, then we can apply an additional outline to the lines.

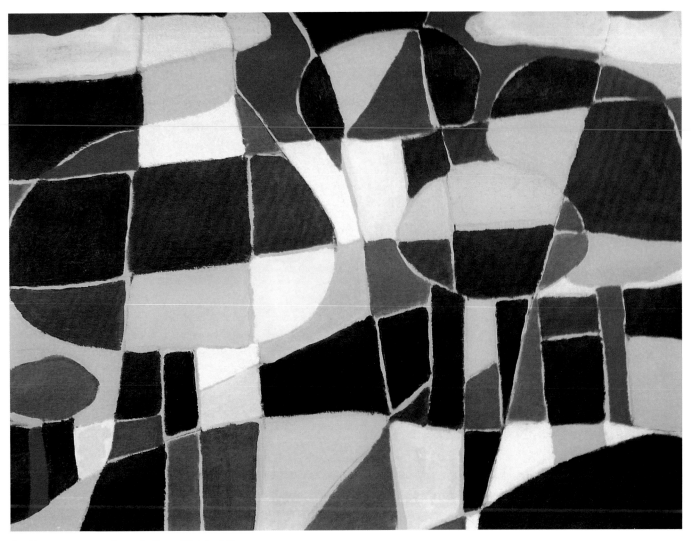

Acrylic on paper, 50 × 60cm (19¾ × 23½in), by J. Beenen.

Study tip 2
When we use a contrasting underpainting the small areas that have not been covered become visible as lines. We have not actually painted the lines ourselves (negative lines). As a picture element, lines are more jagged, irregular and therefore more expressive than if we had painted these lines on top.

Study 36 Inspired by a nature photograph

Study task: abstract and translate the information from a nature photograph into a spontaneous and expressive work.
Materials: canvas, board or paper, acrylic paint, brush and palette knife.
Picture elements: line, form, colour, tone, texture, dynamics, unity and harmony.
Techniques: brushwork, scratching out, knife-work, wet and dry techniques.
Composition: start with the principal shapes in the photograph. Always allow yourself the freedom to add or remove things from the plane division. Use active and passive areas, as you distinguish them from the photograph.

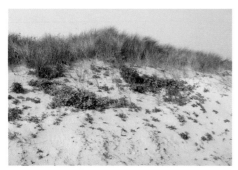

Photograph used as the inspiration.

Details and work sequences.

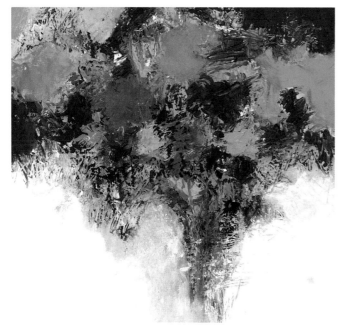

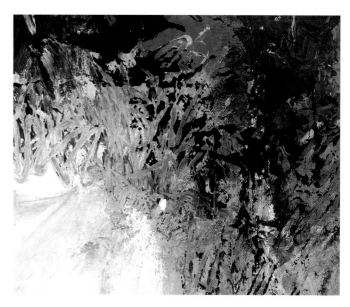

Work sequence

1. Using the photograph as a reference, sketch out a plane division on the support.
2. With pure paint, create various colour fields on the canvas.
3. Mix the colours together while painting, wet-on-wet.
4. Bring texture into the work by scraping across the paint while it is still wet.
5. To finish, paint smooth and even (passive) areas in order to rest the eye and reinforce the active areas (colour and texture).

Study tip

We can use the plane division in our source of inspiration as a starting point, but we can also be inspired by textures. This was how the beach grass in the photograph inspired the use of the scratching technique. In other words, take things from a photograph that prompt you into spontaneous actions and in which feeling plays an important role. If you take this a step further, you will no longer want to depict the information in photographs. Instead of being driven by a visual source (the photograph), your painting will be driven by an internal source (your artistic feeling for colour, composition, unity, etc.), and that is what we should strive towards.

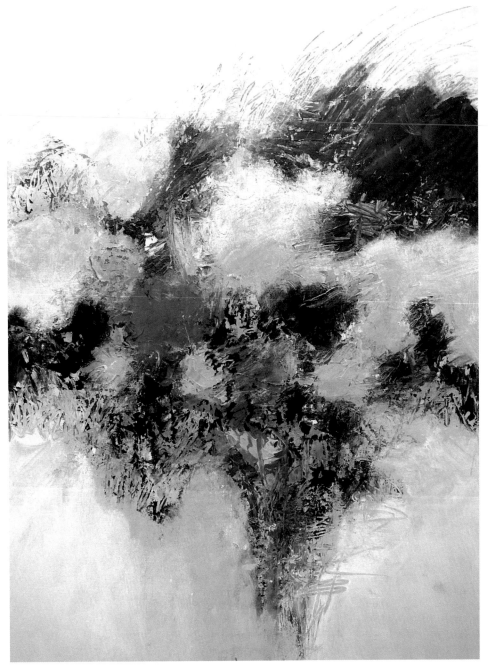

Acrylic on canvas, 80 × 100cm (31½ × 39½in), by R. van Vliet.

Study 37 Inspired by other artists

Study task: allow yourself to be inspired by a painting created by a well-known artist in which the form of the image is inspiring. Purposely choose a different technique for this.
Materials: canvas, board or paper, acrylic paint, sketch paper and fine and medium brushes.
Picture elements: colour, form, line, tone, unity and harmony.
Techniques: line and painting techniques.
Composition: use the composition of the image. Change it if you like.

Work sequence

1 Search in art books or the Internet for a painting with a shape that has special appeal for you. We will 'borrow' this shape for our own work.
2 Paint the whole support in different colours that merge into each other. Allow the colour mixing to take place spontaneously on the canvas. Think about colour repetition and colour variation.
3 Allow everything to dry.
4 As a hand exercise sketch, use a fine brush on paper to paint the shape you have chosen and want to bring to the canvas. Repeating this several times will improve your precision.
5 Finally, using a brush and paint, apply the drawing to the coloured background.
6 Correct any colour or lines where necessary.

Practice sketch based on the painting *Liefdespaar* (Loving Couple) by Otto Mueller. The sketch was created using a continuous line with the help of a computer drawing program.

Study tip

When we use other people's work, we can copy the shape and composition as shown here. However this type of study only makes sense when we learn something or create something of our own. In this case, we are learning to sketch the human form. By doing this we are exercising our feeling for proportion and shape. We are also practising a more spontaneous, expressive method of sketching that does not involve the full outline, but rather a more stylised, often interrupted style of line drawing. By choosing a colour and technique, you are creating your own interpretation.

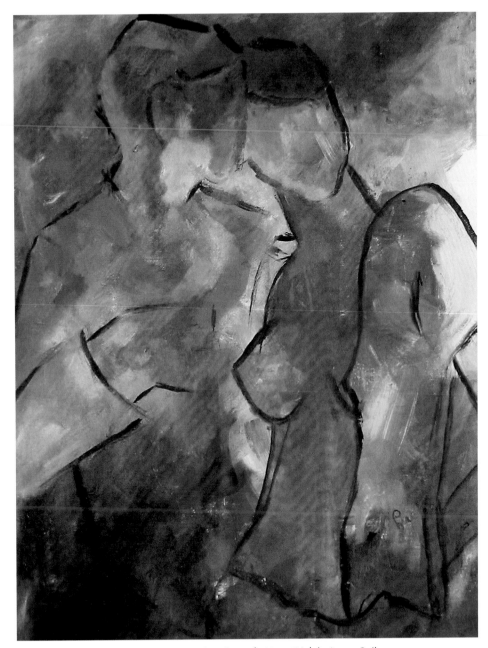

Acrylic on canvas, 60 × 80cm (23½ × 31½in), by L. van Ooik.
Variation on *Loving Couple* by Otto Mueller.

Study 38 Monoprint

Study task: experiment with the printing technique. Start your work by making a simple monoprint from a sheet of paper.
Materials: canvas, board or paper, sheet of drawing paper or newspaper, acrylic paint and fine and medium brushes.
Picture elements: form, colour, line, tone, texture, rhythm, harmony and unity.
Techniques: monoprinting, glazing, wet-on-wet, paint-flow and drip-painting techniques.
Composition: fill the whole canvas with square, free or rounded shapes.

Work sequence

1. Paint your composition in colour on an old newspaper or piece of paper using pure dry paint.
2. Place the wet image face down on your support and apply pressure by gently rubbing the painted image. Remove the paper.
3. Now, using a fine brush and clean water, gently blend the colours while still wet. By using this watery technique, the colours will mix according to the paint-flow principle.
4. Where necessary, paint areas of the print with fairly dry, opaque paint to create tranquillity and in this way enhance the texture of the copy.
5. Allow everything to dry. If you wish, you can use the glazing technique to finish in order to bring unity and harmony to the whole image.
6. You can also enhance the image by using other water-based techniques such as paint splashing and drip techniques.

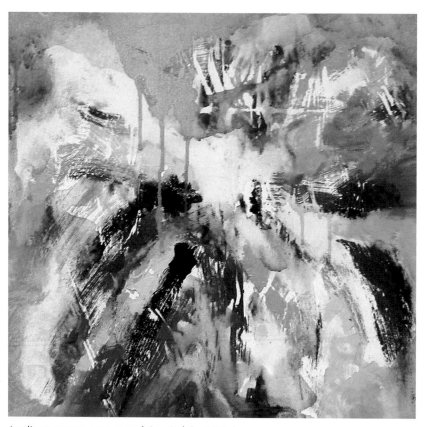

Acrylic on canvas, 40 × 40cm (16 × 16in), by P. Wiekmeyer.

Study tip

Because the technique demands fast, immediate painting, you will need to keep an 'internal picture' in your mind to develop the composition, shapes and the colour division as desired. This requires a lot of experience. If you cannot manage this, then another option is to create a simple colour sketch beforehand with pastels.

Acrylic on canvas, 40 × 40cm (16 × 16in), by A. Stuivenberg.

Study 39 Constructive style

Study task: to build up a free composition using geometric shapes and elaborate with pure colours.
Materials: canvas, board or paper, acrylic paint, palette knife and brushes.
Picture elements: line, form, colour, format, tone, texture, contrast, unity, harmony and equilibrium.
Techniques: brush and line techniques.
Composition: create a shape or line composition that fills the whole canvas with lines and/or shapes running out of the image area. Pay attention to shape variation and equilibrium.

Work sequence

1 First create a distinct design using lines and, if you wish, colours. Place smaller shapes in the centre to enhance the focal point. If necessary, put larger shapes on the outer edge to create calmer areas.
2 Sketch out the line composition on to the support and paint in the lines with black paint.
3 Apply a pure, unmixed colour to all framed shapes. While doing this, stay within the outlines. You can, if you wish, add texture by working painted areas with a knife.
4 Use black and white as well as colours for extra contrast. Alternatively, emphasise the outlines in black paint after you have applied the colours. Do this with a knife or stamp using cardboard to obtain a more irregular, textured and lively line.

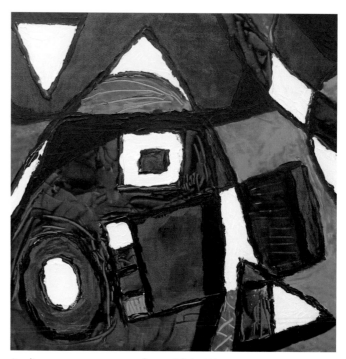

Acrylic on canvas, 30 × 30cm (12 × 12in), by T. Loos.

Study tip

We are all familiar with the constructive works of Mondrian. They are very rigid and purely horizontal or vertical. Furthermore, the colours have not been treated with any texture and the lines are also perfectly straight. This type of study provides a good opportunity for you to loosen the reins and search for your own constructivist style with greater freedom. Similarly, there will be many artists who can inspire us to do something that is just a little different and the result will be a completely personal, surprising elaboration on a simple theme.

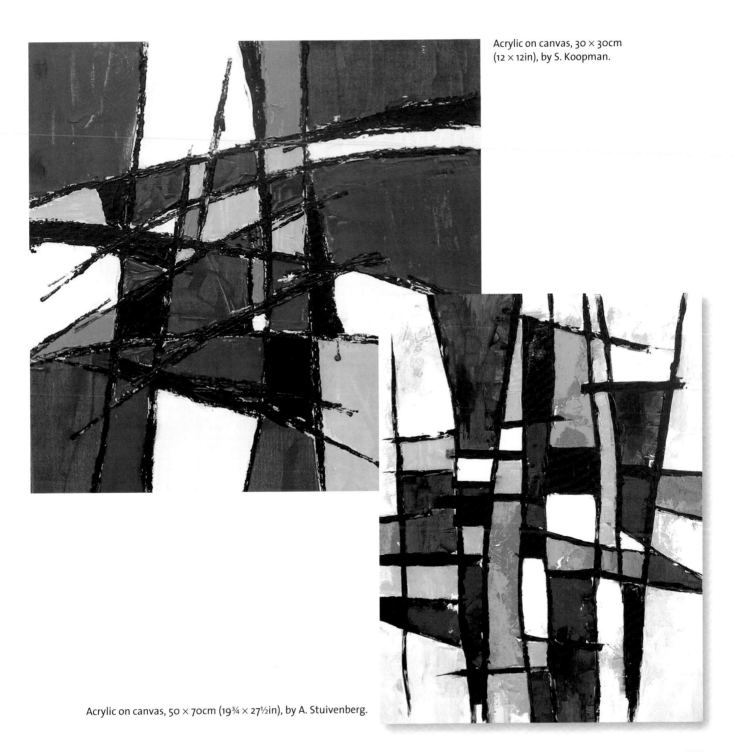

Acrylic on canvas, 30 × 30cm (12 × 12in), by S. Koopman.

Acrylic on canvas, 50 × 70cm (19¾ × 27½in), by A. Stuivenberg.

Study 40 Still life

Study task: create a design based on a still life. Use the rules of abstraction to transform the reality into a completely new image.
Materials: canvas, board or paper, acrylic, brush, tissue paper and gesso or acrylic medium.
Picture elements: line, form, colour, texture, format, tone, unity and harmony.
Techniques: collage, glazing, paint-flow and dry-brush techniques.
Composition: chose a particular composition model with active and passive areas as a starting point, such as a T, L or cruciform composition.

Work sequence

1 Sketch a number of objects based on observations suitable for use in a still life. Use the rules of abstraction and sketch the objects in outline form. Remove the third dimension and bring the objects back to a two-dimensional image.
2 Create a coherent composition by drawing the objects transparently on top of each other.
3 Fix a layer of tissue paper to the canvas using gesso or acrylic medium. Crumple the paper into a ball beforehand and then unfold it. By doing this the tissue paper will give a crackle texture to the artwork.
4 Allow the composition to dry properly.
5 Using a brush and paint, draw an outline of your subject on to the support.
6 Apply watery paint (glazing). Alternatively mix the colours wet-on-wet and let them flow together into the paper.
7 Allow everything to dry and, with a dry brush, gently paint over the texture of the tissue paper (dry-brush technique) with white paint, for example, which will emphasise the texture.

Design sketch.

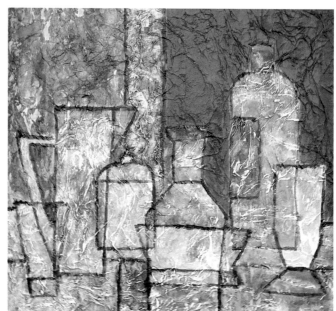

Mixed media in a cruciform or inverted T composition, 50 × 50cm
(19¾ × 19¾in), by J. Meijer.

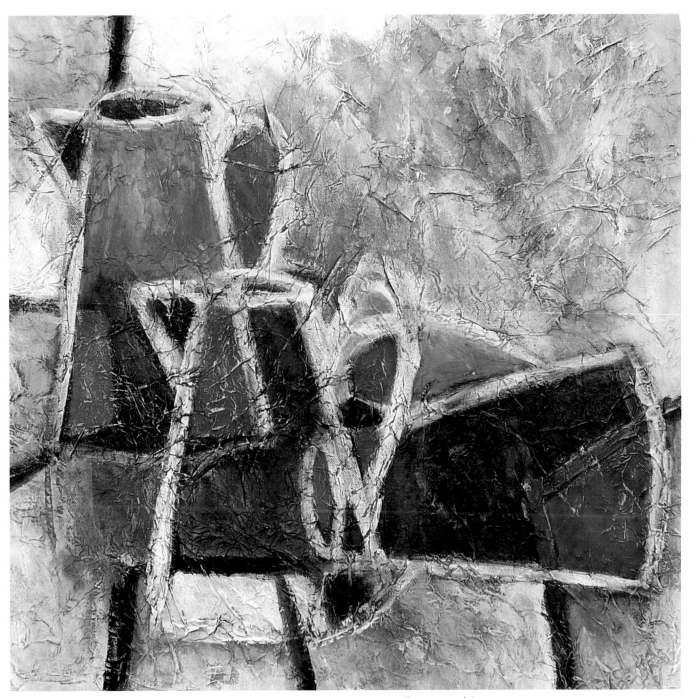

Mixed media on canvas in an L composition, 50 × 50cm (19¾ × 19¾in), by S. Koopman.

Study 41 Line interplay

Study task: create several pieces of work in which the visual language is made up solely of lines.
Materials: canvas, board or paper, acrylic paint, Indian ink, acrylic medium, fine and medium brushes and bottle with a small nozzle.
Picture elements: line, tone, contrast, rhythm, dynamics, unity and harmony.
Techniques: brushwork, line technique with fine brush, and ink and squirt technique.
Composition: work as spontaneously as possible towards a composition that fills the whole canvas and alternate with passive, calm areas if desired.

Work sequence

1 Mix several parts of black paint with several parts of water and acrylic medium in a bottle with a small nozzle.
2 Determine in your mind where the emphasis will appear in the composition then, using the bottle, allow your 'rhythmical line play' to gently run across the canvas in a continuous line.
3 Using a brush with clean water, go along the black areas while still wet and allow a little of the paint and water to blend and create grey shades. At the same time, brush the 'grey' away across slightly larger areas. By doing this you will create a visual bridge between the contrasting black and the white of the support.
4 You can add additional line effects if necessary with a fine brush and ink.

Further studies

Repeat this study on a support with a different format. Alternatively, switch from using angular lines to rounded, wavy lines (see the example opposite). If you like, you can superimpose another colour and/or various colours in the same composition.

Detail from the line study.

Line study with round shapes.

Study tip

'Drawing' with a bottle requires a continuous line and spontaneous movements. The viscosity of the paint will partly determine how thick the line will be. Practising beforehand will help you discover how much water you need to add to the paint in order to create a flowing stripe. Try this technique with a fine brush and ink too.

Acrylic on canvas, 20 × 110cm (8 × 43¼in), by R. van Vliet.
Detail from the line study.

Study 42 Working from an abstract photograph

Study task: use an 'abstract' photograph – of an old, weather-worn wall, for example – and take the cracks and marks as a starting point for your composition.
Materials: canvas, board or paper, acrylic paint, brush, palette knife, texture paste, gesso, sand, fine brush and ink.
Picture elements: line, colour, form, texture, tone, contrast, unity and harmony.
Techniques: knife-work, brushwork, fine-brush drawing, scratching-out and dry-brush techniques.
Composition: the marks on the wall may determine the form of the composition. These marks act as active shapes while the remaining space acts as a passive area.

Work sequence

1 Apply a rough layer of texture paste and gesso. Sprinkle sand over some areas if required. By doing this we will re-create the qualities of the old wall.
2 Allow everything to dry thoroughly.
3 Using a fine brush and ink, sketch the shapes roughly on the support.
4 Apply colour to the whole area. Use intense colours in the active areas and soft, fainter hues for the surrounding areas.
5 You can add further texture when painting by scratching into the wet paint with your knife.
6 If you want, you can blur the line effect by blending slightly with a soft brush so that the underlying colours penetrate through.
7 Also apply a thin layer of paint to the passive areas, so that the underlying colours are dimly visible through it. In this way the passive surrounding shapes are also interesting to look at. This will also create optical colour blending. This effect occurs when thin and transparent layers of colour are superimposed.

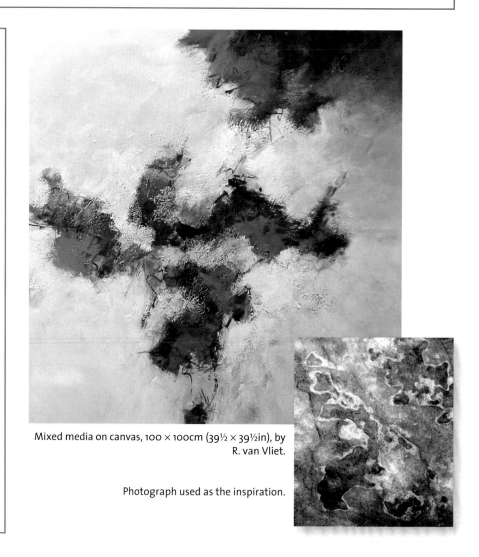

Mixed media on canvas, 100 × 100cm (39½ × 39½in), by R. van Vliet.

Photograph used as the inspiration.

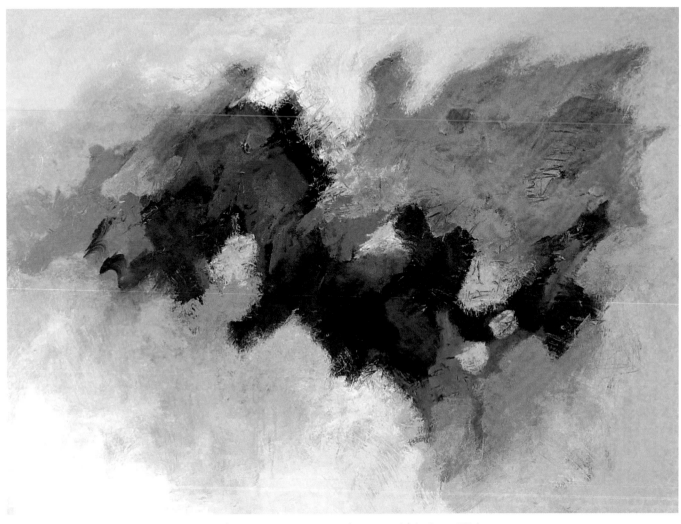

Acrylic on canvas, 100 × 120cm (39½ × 47¼in), by R. van Vliet.

Study tip

Walls that are covered with a layer of plaster sometimes show cracks, damp patches and other damage over time. We also see similar effects in rocks, roads, sandy plains and layers of earth. These all provide excellent prompts for creating a composition. Keep your eyes open wherever you are and take as many photos as possible of any such observations. For painters, these are now simply a source of inspiration. However, you should deal with these photographic materials in a free manner. You do not have to paint that piece of wall or rock exactly, so the colours and shapes do not have to correspond to those in the reference. It is merely a prompt to allow you to start – nothing more and nothing less.

Study 43 Static and dynamic

Study task: use the contrast between static and dynamic to compose two different works. Use the same colour scheme for both but choose different techniques.
Materials: canvas, board or paper, acrylic paint, palette knife and an object for stamping lines.
Picture elements: line, form, colour, texture, tone, unity, harmony, dynamics, equilibrium and balance.
Techniques: knife-work, line stamping, paint application and wiping techniques.
Composition: for the dynamic composition, use a diagonal composition with wavy shapes; for the static composition, use rectangular shapes with the emphasis on horizontal and vertical equilibrium.

Work sequence A – static and regular

1 Without marking out a sketch or a plane division, start immediately by placing rectangular shapes on to the support using a knife and colour. Begin in the centre of the image and work your way towards the edges.

2 Start with the lightest colour and end with the darker features. Because the work does not have to dry between layers, the colours can mix continuously.

3 Repeat the process a second and third time with each colour as desired. Always bear in mind the colour and form repetition, contrast and variation, and search for equilibrium and balance with respect to the horizontal and vertical components.

4 Finally, for extra emphasis, add some stamped line effects.

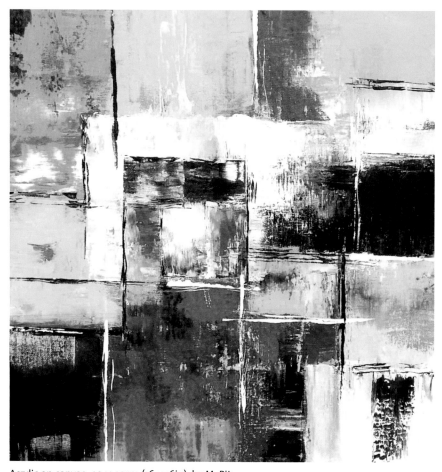

Acrylic on canvas, 40 × 40cm (16 × 16in), by M. Pit.

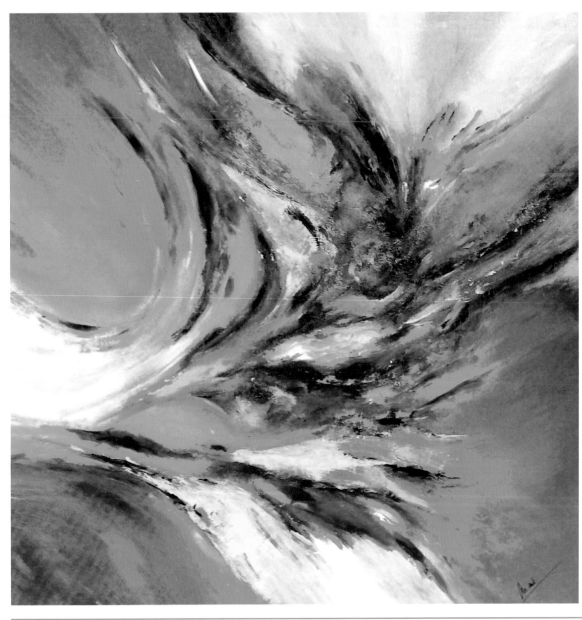

Acrylic on canvas,
80 × 80cm
(31½ × 31½in), by
M. Pit.

Work sequence B – dynamic and diagonal
1 Place diagonal, sweeping shapes on to the support.
2 Apply paint and brush the colours together with your fingers or a cloth so that they softly overlap.
3 Add contrast and tonal intensity for emphasis.

Study 44 Picturing boats

Study task: create a study using the general shape of sailing boats as your starting point.
Materials: watercolour paper, pencil and sketch paper, oil pastels, watercolour paint and watercolour brush.
Picture elements: colour, form, line, unity, dynamics, rhythm and harmony.
Techniques: pastel, paint-flow and doodling techniques.
Composition: create a line composition that fills the whole canvas and does not have any focus or passive areas.

Work sequence

1 In order to create the most spontaneous possible line composition, it is recommended that you practise beforehand by doing at least ten sketches to exercise your hand.

2 Now repeat the doodle with a pencil and paper. Note that the intention is not to copy a composition that has been completed already because this would completely lose the spontaneity required.

3 Now draw over the pencil lines using oil pastels.

4 Colour in the whole image with watercolours and work wet-on-wet to allow the colours to flow into each other.

5 Add a second layer of paint, if necessary, to enhance the intensity of the colours.

Creating line compositions in a continuous line is also a great way to practise using a computer drawing program.

Study tip

The doodling technique should be thought of as allowing a composition to exist spontaneously by means of one single, continuous, non-stop line. This requires a lot of experience. Regular sketching based on observations and then sketching from memory or your imagination are essential for this.

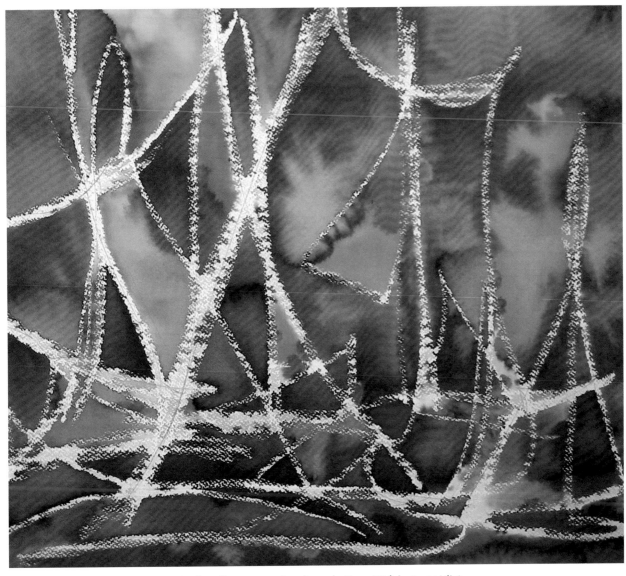

Mixed media on paper, 60 × 60cm (23½ × 23½in), by R. van Vliet.

Oil-pastel resist

Oil pastels are made from a greasy substance that liquid paint cannot adhere to. It therefore acts as a resist and blocks out the watercolour. White pastel crayon will always appear through paint as a white line.

Study 45 Collages with nature

Study task: use materials from nature as your visual language.
Materials: canvas, board or paper, acrylic paint, brush and filler such as acrylic medium, gel or powdered stone.
Picture elements: colour, form, line, tone, texture, movement, direction, rhythm and harmony.
Techniques: brushwork, knife-work, collage and incorporation techniques.
Composition: allow the composition to grow through the arrangement of materials. Use the whole image area and allow shapes to extend beyond the edges to indicate space.

Work sequence

1 Look for natural materials such as leaves, grass, bark, etc.
2 Arrange your material on the support and fix it using a thick layer of paint or acrylic medium. To prevent these materials from coming loose later on, you need to dry them thoroughly first, expel any air and firmly glue the whole surface of each item.
3 Leave to dry and then add colour.
4 Integrate the materials into your artwork. It is important here that both the natural shapes and the surrounding areas are given the same colour shades in some places. In this way there will be greater cohesion between the materials and their surroundings.

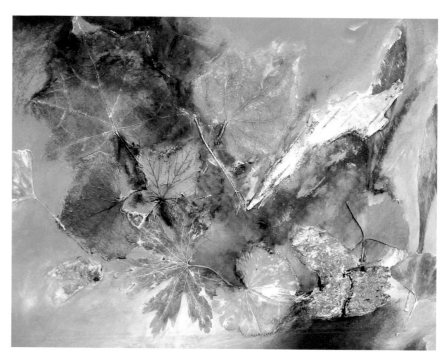

Mixed media on paper, 50 × 70cm (19¾ × 27½in), by A. Verhagen.

Study tip 1

When you use natural materials in your work, ensure that they are dried by placing them as flat as possible on to moisture-absorbing materials (e.g. old newspapers or tissue paper). These natural materials serve as shape elements in your work, as shown in the piece by A. Verhagen (above). They can also add line and rhythm as shown in the work with grass by I. Kiesling (opposite).

Study tip 2
It is best to attach tough and weather-beaten materials like grass with a strong adhesive such as wood glue. Such materials can also be glued very effectively with heavy gel, texture paste or with paint thickened with powdered stone, as in I. Kiesling's piece.

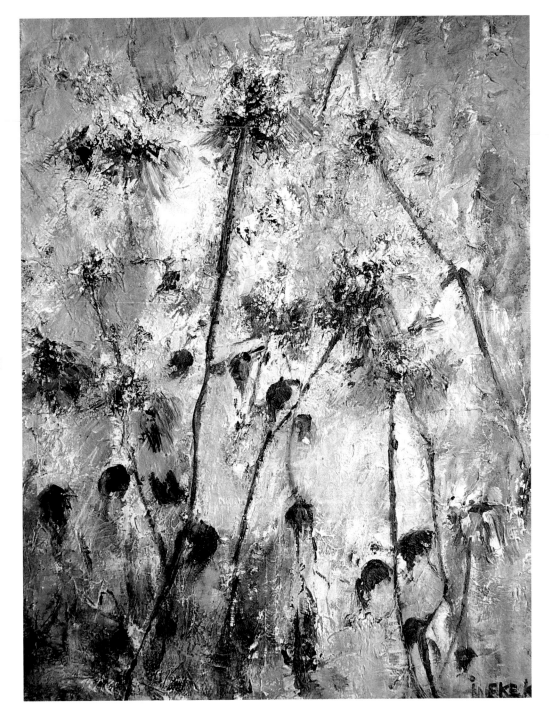

Mixed media on canvas, 60 × 80cm (23½ × 31½in), by I. Kiesling.

Study 46 From abstract to figurative

Study task: begin with an abstract, free work and see whether something figurative can be created from this.
Materials: canvas, board or paper, acrylic paint and brush.
Picture elements: form, colour, texture, tone, line, unity, dynamics, harmony, equilibrium and balance.
Techniques: free painting with spontaneous mixing and line emphasis.
Composition: a free composition, based on spontaneously divided areas of colour.

Work sequence

1 If necessary, sketch out a simple, complete, non-figurative plane division on the canvas, otherwise start without this.
2 Spontaneously introduce areas of colour and think about harmony by using colour repetition.
3 Play with colour mixtures and, if necessary, add a second layer of colour.
4 Stand at a distance from the work and see whether there are any recognisable shapes. If not, continue experimenting with colour, lines or textures. If you can recognise shapes, then try to emphasise them using lines, colours, tone, etc. Do not show the shape too clearly otherwise you will just see this shape and ignore the rest of the work. Our mind has a tendency to become lazy once we have seen something we recognise.

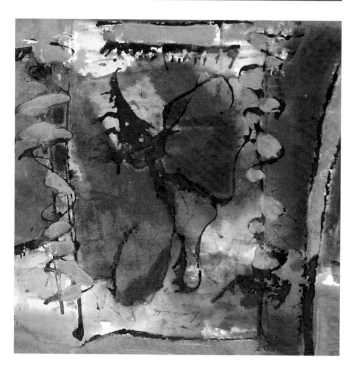

Study by R. van Vliet.

Study tip

To get a process like this started, you can look thoroughly at the experiments you made earlier and 'rejected', or at incomplete works. There is usually something still to be discovered. This is definitely the case when you turn them around and take a good look from a different angle. Maybe it will inspire you to continue working in a direction, either recognisable or not.

Do not plan ahead

This type of study is actually very difficult to carry out deliberately. Seeing something recognisable in a study that started out with total abstraction is a chance occurrence and as such cannot be guided. Furthermore, if you begin this study with the idea that you will soon have something recognisable, subconsciously you will tend to take this into consideration from the beginning and that is exactly what you want to avoid. In other words, this type of study only works when you do not plan to create something recognisable in advance.

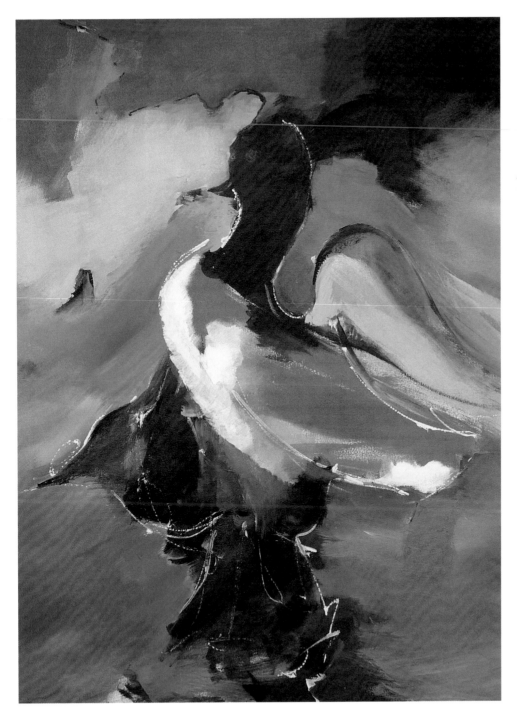

Acrylic on canvas, 50 × 70cm (19¾ × 27½in), by J. van Treuren.

Study 47 From dark to light

Study task: create a layered artwork using lots of textures and a very light colour scheme.
Materials: canvas or board, acrylic paint, brush, palette knife, atomiser and old newspapers.
Picture elements: line, colour, texture, tone, unity, harmony and depth.
Techniques: collage, texture, scratching out, drip-painting, line and scumbling techniques.
Composition: allow the composition and the plane division of the features and textures to appear spontaneously while painting. This method tends towards a central focal point.

Work sequence
1 Start with a layer of randomly placed pieces of newspaper.
2 Paint the whole area in bright, strong colours using expressive brush strokes and spontaneous mixing. Repeat with a second layer.
3 Rough-up the surface by scoring and scratching with a knife.
4 Bring contrasting lines and features into the central area using black paint.
5 Allow everything to dry properly.
6 Next, brush lightly with thin, white paint across specific areas (scumbling technique) and in this way weaken the underlying colour intensity. Continue until the work has a high-key effect.
7 Spray on water using an atomiser to allow white lines to appear, which will strengthen the visual language.
8 Paint areas where necessary with opaque paint in order to bring calm to the piece.

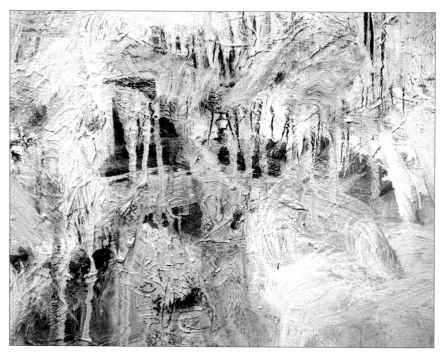
Detail.

Working in layers
This type of work can be built up by continuously painting one layer on top of another. It is a skill to allow something from each preceding layer to remain, and results in a certain depth that you can literally see.

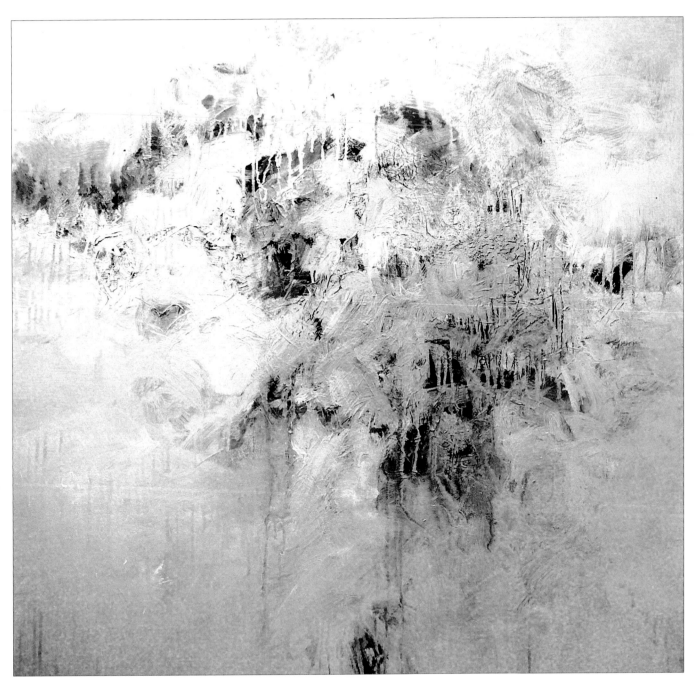

Mixed media on canvas, 100 × 100cm (39½ × 39½in), by R. van Vliet.

Study 48 Line composition

Study task: design a composition using continuous line technique and elaborate with a particular texture.
Materials: canvas or board, acrylic paint, brush, charcoal or chalk, and sawdust or sand.
Picture elements: form, line, colour, texture, format, tone, unity, harmony, equilibrium and balance.
Techniques: painting, texturing and scratching-out techniques.
Composition: create a free composition with a central focus and lines that enter and leave the image; allow the composition to originate from one continuous line that is created in a single movement.

Work sequence

1 Select in advance angular and straight or alternatively rounded, wavy lines. Create the composition on the canvas using one continuous line in either chalk or charcoal.
2 Using the brush and paint, emphasise lines in the composition.
3 Choose a 'warm' colour scheme and give consideration to tonal variation.
4 Work on the different shapes using clear colours then sprinkle sawdust or fine sand on to the paint while it is still wet. These materials will stick easily to the acrylic paint. They will reduce the intensity of the colours and give a fuzzy effect.
5 For variation, you can also paint certain areas without adding anything else.
6 Finish, if you wish, with several scratched features to emphasise the texture.

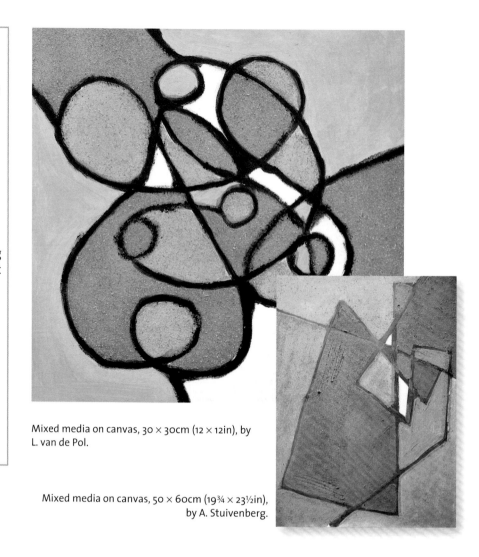

Mixed media on canvas, 30 × 30cm (12 × 12in), by L. van de Pol.

Mixed media on canvas, 50 × 60cm (19¾ × 23½in), by A. Stuivenberg.

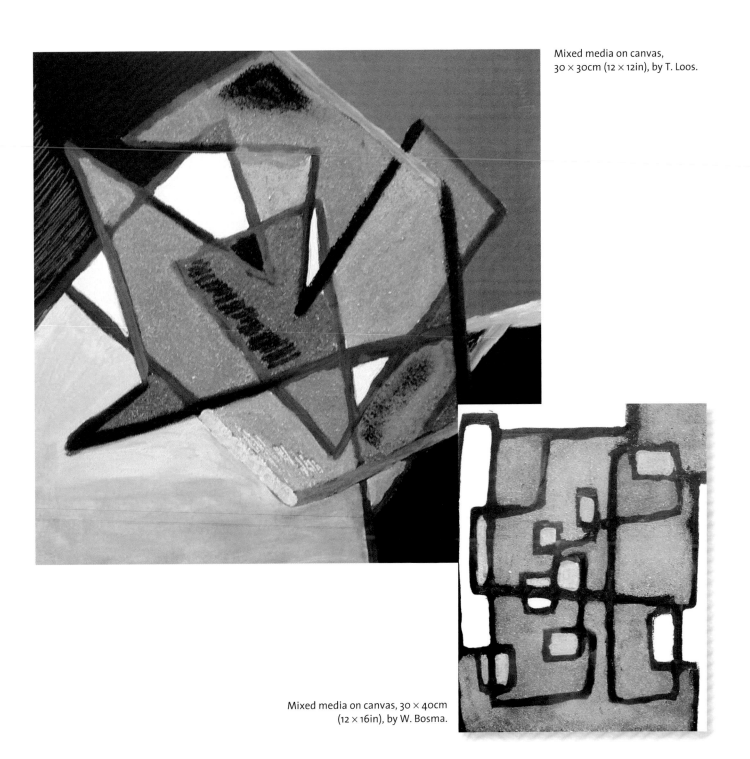

Mixed media on canvas,
30 × 30cm (12 × 12in), by T. Loos.

Mixed media on canvas, 30 × 40cm
(12 × 16in), by W. Bosma.

Study 49 Musical atmosphere

Study task: create a work based on the theme 'music'. Express mood and atmosphere as much as possible.
Materials: canvas or board, charcoal or pencil, acrylic paint, brush, palette knife and collage material.
Picture elements: form, colour, line, texture, tone, repetition, unity and harmony.
Techniques: collage, glazing, incorporation, knife-work and dry-brush techniques.
Composition: create a free composition in which the collage material, shapes and contrasts act as focus; involve the whole image.

Work sequence

1 Design a work, based on your ideas of 'atmospheric music', which expresses this theme.
2 Sketch out your design on the support.
3 Stick the collage pieces on to the canvas, as desired, using paint, glue or acrylic medium.
4 Glaze the whole area with transparent paint.
5 Give it more colour and add texture, if you wish.
6 Work using a thin, transparent layer of paint and blend the colours together to produce soft, atmospheric transitions.
7 If you wish, add line and contrasting features.

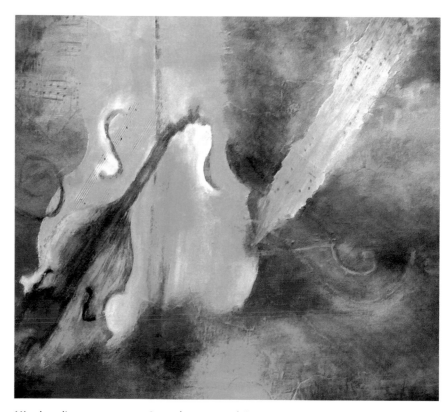

Mixed media on canvas, 50 × 60cm, (19¾ × 23½in), by H. van Gemeren.

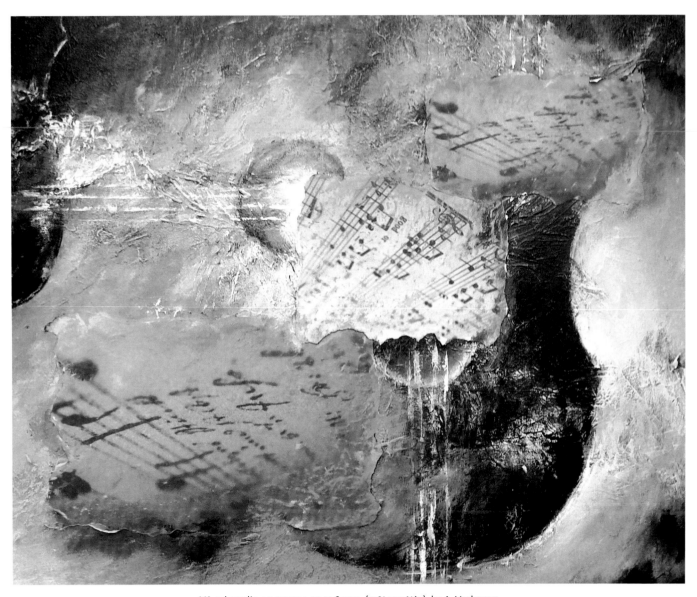

Mixed media on canvas, 50 × 60cm, (19¾ × 23½in), by A. Verhagen.

Study 50 Nature's colours

Study task: create a study that is as spontaneous as possible and think here about plants in bloom hanging from a fence or balcony.
Materials: canvas, board or paper, acrylic paint, palette knife and brush.
Picture elements: line, form, colour, tone, texture, harmony and unity.
Techniques: expressive painting, knife-work, brushwork and scratching-out techniques.
Composition: choose a shape that combines with the theme of the task, for instance an N-, T- or M-shaped composition. Think here about using passive surrounding areas to alternate with the active focal area.

Work sequence
1. Begin with an underpainting.
2. Choose a composition design and roughly sketch the main shapes on to the support using a brush and paint.
3. Choose the technique that you want to use and give colour to everything by using a knife or brush.
4. Work on the desired texture by scratching or brushing the paint while it is still wet.
5. Finish by painting the calm, passive areas evenly and smoothly.

Details from the work given opposite, showing the expressive painting technique.

And again
Once finished, start this same study again immediately, but change the composition, colour scheme and techniques used. This type of theme can eventually lead to many different variants and it is especially suited to exercising your powers of expression. Once you are already painting, you can then easily drop the theme and concentrate more on varied paint styles. In this way, a figurative theme can ultimately lead abstract painters to total abstraction and the freedom of action that goes with this. You will discover for yourself the path to creativity, power of expression, originality and individuality. This is the ultimate aim of the Abstract Painting Method.

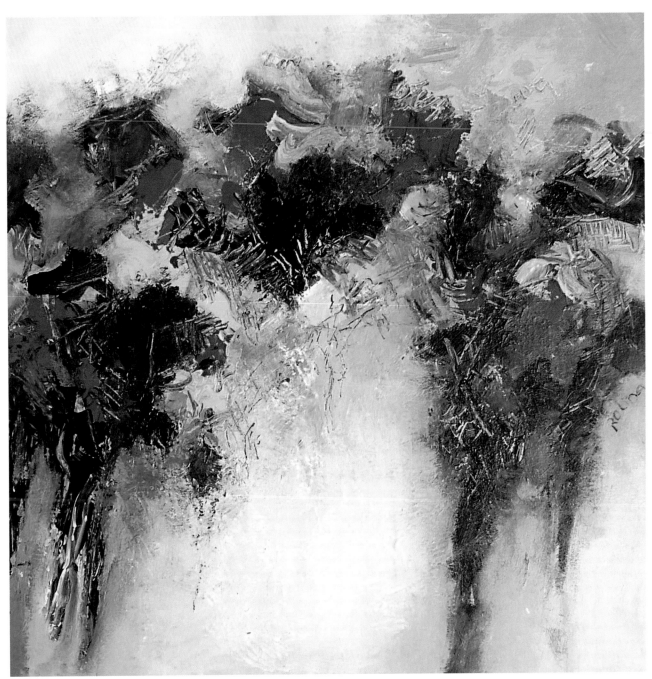

Acrylic on canvas, 80 × 80cm (31½ × 31½in), by R. van Vliet.

7 One hundred ideas to start

If you have followed the detailed study tasks in this book, which gave you the answers to the questions 'what?' and 'how?', it is now time for the next step. For that purpose I am going to give you one hundred extra ideas to start you off. However, this time I will only briefly describe 'what' you can paint. You will have to fill in the 'how' for yourself. In short, I will help you to start, but you have to reach the finish on your own. Incidentally, my students almost always reach the finish and, as you have seen in this book, the results are often beautiful and personal. Furthermore, I have purposely not included any illustrations. This way your own interpretation will be a lot stronger and you will come closer to your goal: the path to individuality and originality and creating abstract work on your own.

Let's get started. Get your imagination and fantasy working until you are sufficiently inspired and motivated to begin.

1. Find a black-and-white photograph from a newspaper. Choose some interesting shapes from this to use as the basis for your composition and apply colour throughout.
2. Ask yourself: 'What can I do with a box of felt-tip pens?'
3. Leaf through an art book and get inspired by one of the images. (Put the book away before you start to avoid being influenced too much.)
4. Draw several household appliances with your eyes closed and create a number of compositions with these.
5. Use textiles with different patterns as a starting point.
6. Elaborate the picture element 'rhythm' by using thin twigs or sticks as line elements.
7. What can you do with a palette knife?
8. Bring the theme 'transport' into an image.
9. Be inspired by an advertising leaflet.
10. Cover a work of your own that did not live up to your expectations with a layer of transparent tissue paper and make something different out of it.
11. Create three different pictures with the theme 'tree'.
12. Use an old newspaper as collage material and use the letters and text as the picture language.

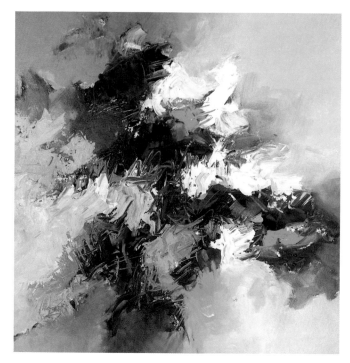

Acrylic on canvas, 70 × 70cm (27½ × 27½in), by R. van Vliet.

13 Find some stones with different patterns, lines and colours and use the patterns as the starting point for a design.

14 Search for things to print with and use these to stamp patterns and rhythms on to your work.

15 Collect a number of objects and analyse them on the basis of picture elements. Create a composition from these that you can further elaborate. Think also about variations in form and texture.

16 Take one of your works that turned out well. Try to find out why it is good and use the results of your research as the basis for a new picture.

17 Use an aerial photograph of a city or landscape as the basis for a plane division.

18 Go to the art shop and buy paint in three new colours. Experiment with these at home and discover which new nuances you can create from them.

19 Use a close-up photograph of something from nature for your plane division.

20 Think about the concept of 'accumulation' and elaborate this.

21 Think of a certain piece of music and visualise it.

22 Experiment with using only wash techniques.

23 Create a work based on the style of a painter you admire.

24 Search for a specific detail in your own works and use this small element as the basis for a new work in a large format.

25 Use a picture of layers of earth as your starting point.

26 Search for unusual materials from which to make a collage.

27 Think of ten titles for a painting and create a painting based around the most inspiring one.

28 Make an acrylic painting without using a brush or palette knife.

29 Read some poetry and be inspired by it.

30 Try to remember a TV programme that impressed you and create something that would combine with this.

31 The gift shop needs new wrapping paper soon. Design an attractive pattern for this.

32 Create a painting in which the picture language is composed of the shapes of painting equipment.

33 Use a microscopic photograph of gems, for example, as a starting point. These types of photographs usually have excellent colours and patterns.

34 Choose a kitchen utensil and sketch it from different angles. Use the various shapes as the basis for a plane division.

35 Use a photograph of a landscape as the starting point for a material painting.

36 Use a paint roller to paint rectangular or alternatively wavy shapes.

37 Think of shards of broken glass and create a composition with this in mind.

38 Choose the profile of a city in the distance as your starting point.

39 Take a close-up photograph of a piece of bark and create something from this.

40 Use grasses and other plants to make a dynamic collage.

41 Experiment with acrylic paint and oil pastels.

42 Search for a group photograph in a newspaper and use this to define your composition.

43 Create a double composition and superimpose this on to your painting.

44 Take photographs of rocks and look for patterns and lines on which you can base your painting.

45 Create a horizontal design and elaborate it vertically.

46 Go over your work with a passe-partout frame or a viewfinder and find a new idea to paint.

47 Branches and leaves are suitable for various elaborations – create four of them.

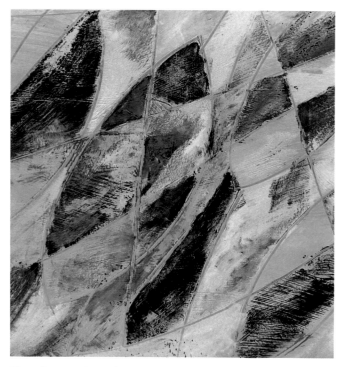

Monochrome colour scheme.

48 Create an image that goes with the last book you read.

49 Paint part of your studio or workspace and abstract it.

50 Create a study that emphasises contrast.

51 Make use of geometric forms.

52 Create a painting in very dark colours.

53 Bring your favourite song into an image.

54 Create a painting in soft pastel shades.

55 Work with a monochrome colour scheme.

56 Opt for a black-and-white elaboration of a work.

57 Allow yourself to be inspired by the shapes of clouds.

58 Create an abstract painting of your garden.

59 Create a composition with a lot of passive space and only a few active areas.

60 Cut out a number of irregular shapes from cardboard and use these to print on your work. Think about rhythm and the repetition of forms and colours.

61 Create a painting using four different techniques.

62 Cut out a number of paper shreds. Throw them randomly on to your underpainting and create a shape composition.

63 Create a thick relief underpainting using texture paste and sawdust.

64 Compose a work using your initials as the shape.

65 Pour liquid paint on to the support and splatter and splash the remaining areas with colour.

66 Use neutral-coloured textiles and different textures as material for a collage.

67 Use the shape of a chair or a boat to create a composition.

68 Create a composition from closed, overlapping forms.

69 Create visual textures with a paper ball.

70 Begin your work with a monochrome print.

71 Do something with the theme 'water'.

72 Emphasise dynamics and motion.

73 Create an image of your holiday.

74 Start with a Y or T composition.

75 Choose a life study as a starting point.

76 Use leaves as material for a collage.

77 Design a painting in the style of Mondrian.

78 Experiment with texture paste and gel medium.

79 Gather rubbish or material from the garage or shed to sketch and choose interesting parts as a basis for a plane division.

80 Create a work using a piece of cardboard as your only tool. Try to find out what you can do with this.

81 Do as Matisse did – cut shapes out of coloured paper and paste them on to a canvas as a collage.

82 Create three different elaborations using an apple as the subject.

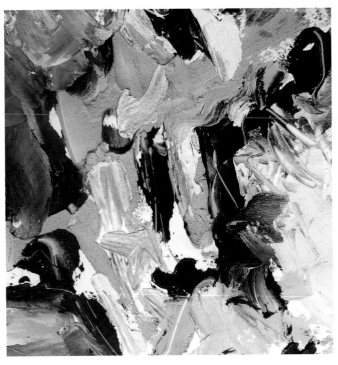

Dynamics and movement.

91 Try to bring to your canvas the atmosphere of the 'feeling of home'.

92 Ask your family to pose and create a group portrait.

93 Design a pattern for a new type of wallpaper.

94 Create a number of plane divisions in rough sketches and elaborate one of these.

95 Make a composition with mask-like shapes that are superimposed and drawn through each other.

96 Draw an animal in profile and use it to compose a work.

97 Create a composition using pieces of coloured paper and use it as an example for a piece of work.

98 Create a composition with rounded and straight lines and superimpose them to further elaborate the design.

99 Create a spontaneous material study using felt-tip pens and ink or pastel crayons, and watercolours or gouache and pastel, etc.

100 Gather together all of the materials that you have and create a work using mixed-media techniques.

83 Design a few stamps (linoleum cut-outs) and print a pattern that fills the whole area.

84 Create a flowery painting.

85 Make a work that reminds you of stained-glass windows.

86 Design a landscape, superimpose a screen composition on top of it and colour it.

87 Create three different stencils and use the stipple technique to create a pattern that fills the whole canvas.

88 Tear up an old work that was created on paper and make a new composition.

89 Choose the title of a book and design an illustration to accompany it.

90 Take a number of abstract photographs. Enlarge copies of them and make a collage.

8 Conclusion

After all of these studies and inspiring ideas, you should have gained a lot of knowledge and experience, and you are now ready to map out your own route.
I would like to give you some final tips to keep in mind.

- Follow your own way and don't be influenced too much by other people.
- Make time to keep learning and experimenting.
- Do not copy paintings by other people.
- Open your mind to unusual inventions and avoid clichés.
- Dare and do – without taking risk there is no renewal and discovery.
- Choose for yourself and never work just for the 'market'. Sales are not your goal but enjoying the creative process is.
- Accept and appreciate what you are able to do.
- Develop healthy self-criticism and keep a close eye on quality. Always avoid showing imperfect work or presenting it as 'art'.
- Open your mind as widely as possible to any form of inspiration.
- Always strive for honesty in regard to originality and individuality.
- Aim for optimal freedom and childlike frankness. Relax and let it all happen. Choose spontaneity and intuition and you will discover that your feelings, nature and whole being will be reflected in your work.

The Abstracting Painting Method and the lessons described are all my own work. They reproduce my experiences as a visual artist and teacher. In addition to my own work, a large proportion of the images in this book are by students. I would like to thank them for their cooperation. This book has become so varied partly because of them.

Through this book, I wanted to help you develop a more provocative way of painting. It is not important whether you are a fan of abstract or figurative painting: getting to know the Abstract Painting Method shows you the way to yourself, your inner self, to your own talent. I hope that, by following this road, you have discovered and experienced the essence of free painting.

I wish you much success.
ROLINA VAN VLIET

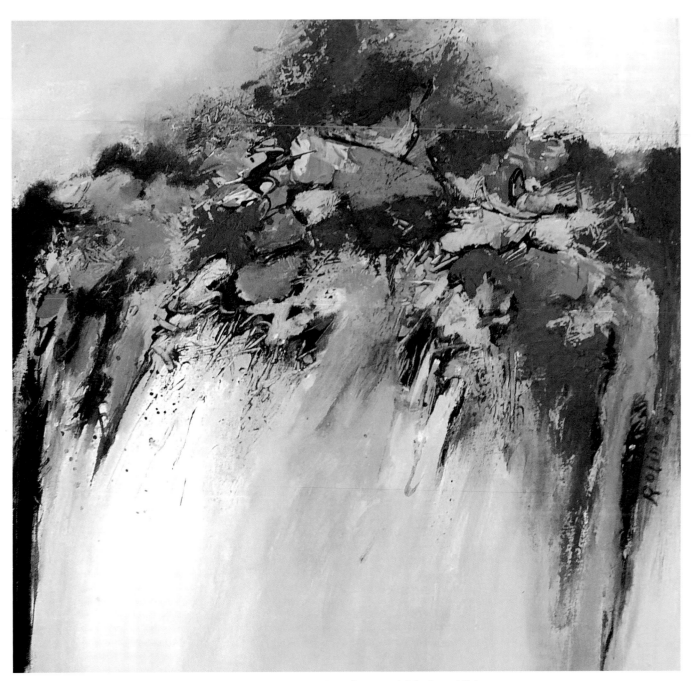

Acrylic on canvas, 80 × 80cm (31½ × 31½in), by R. van Vliet.

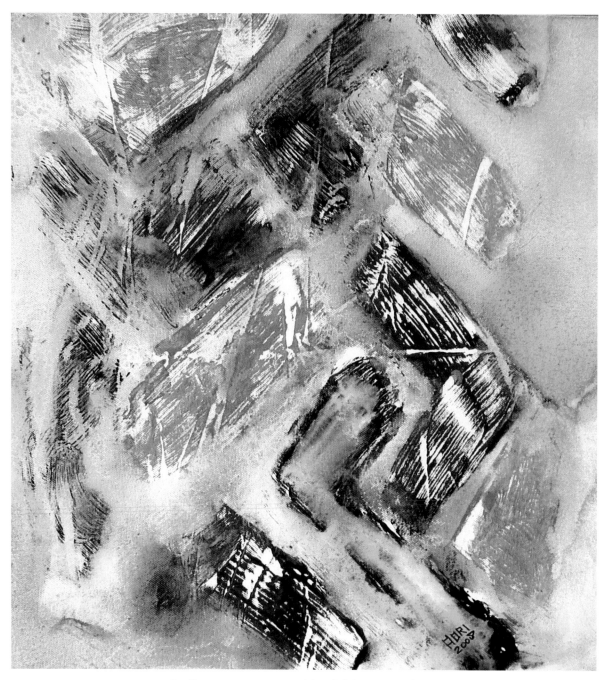

Acrylic on canvas, 40 × 40cm (16 × 16in), by A. Stuivenberg.

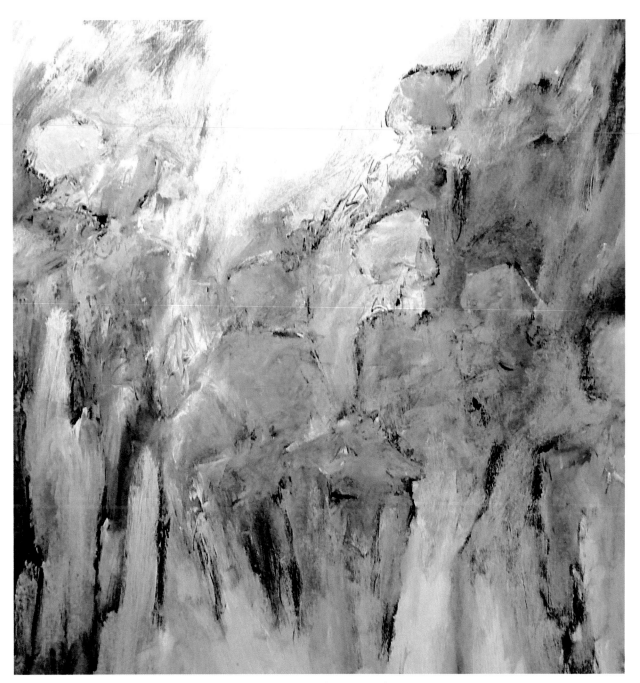

Acrylic on canvas, 100 × 100cm (39½ × 39½in), by R. van Vliet.

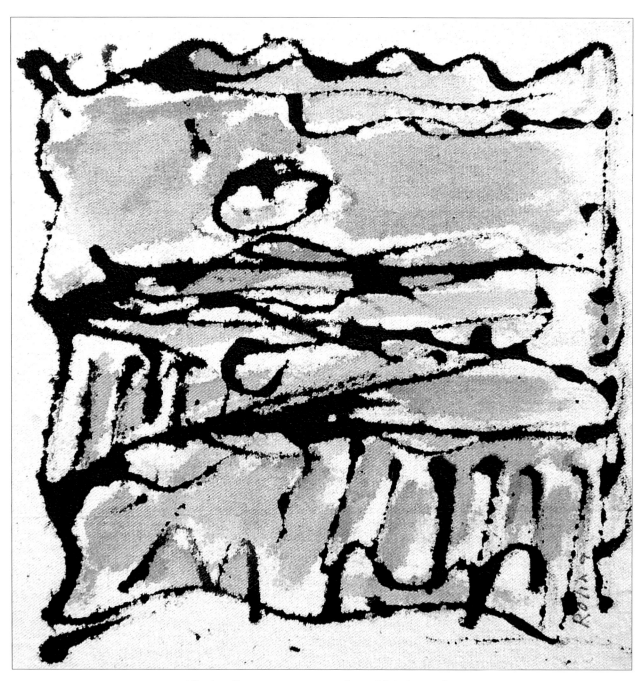

Mixed media on canvas, 30 × 30cm (12 × 12in), by R. van Vliet.

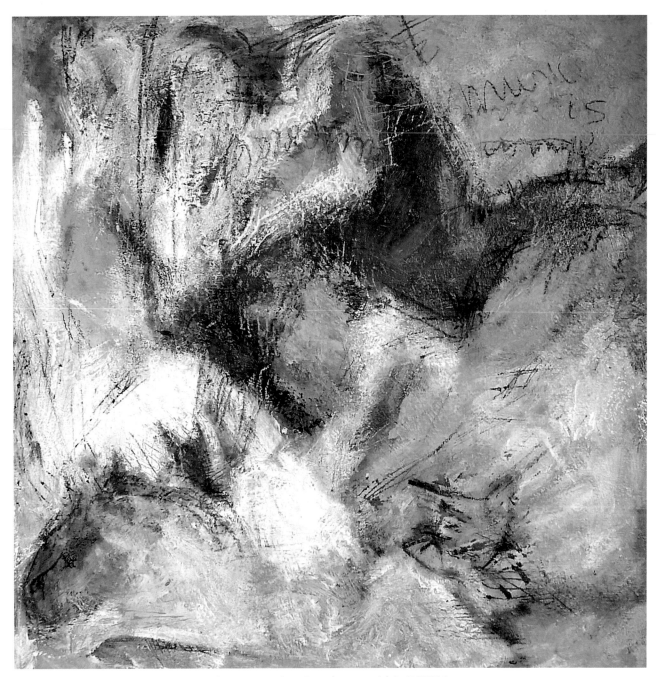

Acrylic on canvas, 80 × 80cm (31½ × 31½in), by B. Wildstrom.

Acrylic on paper, 50 × 60cm (19¾ × 23½in), by S. Koopman.

First published in Great Britain 2011 by Search Press Limited,
Wellwood, North Farm Road, Tunbridge Wells, Kent TN2 3DR

Originally published in The Netherlands as *Abstract, een bron van inspiratie* by De Fontein Tirion, Uitgevers, 2009

Copyright © Rolina van Vliet

The publishers acknowledge that 'Rolina van Vliet' asserts the moral rights to be identified as the Author of this Work.

English translation by Cicero Translations Ltd

English edition produced by GreenGate Publishing Services, Tonbridge

ISBN: 978-1-84448-715-8

Printed in China